IMAGES
of America

JAMESTOWN

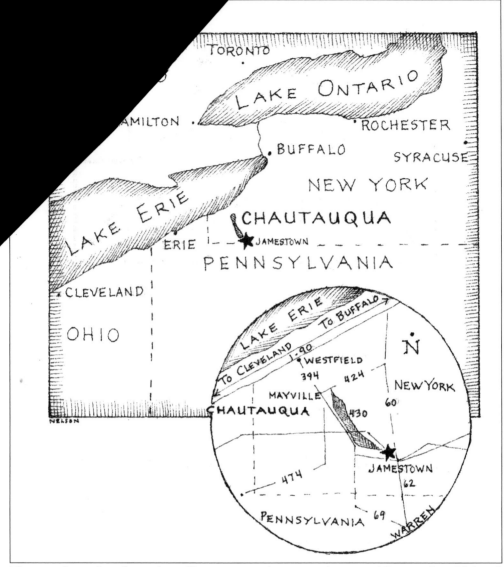

This map shows the relationship of Jamestown to the surrounding area. (Courtesy Jane Nelson.)

IMAGES
of America

JAMESTOWN

Kathleen Crocker and Jane Currie

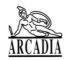

ARCADIA

First published 2004
Reprinted 2004, 2005

Published by Arcadia Publishing,
Charleston SC, Chicago IL, Portsmouth NH, San Francisco CA

Printed in Great Britain

Library of Congress Catalog Card Number: 2003116049

For all general information, contact Arcadia Publishing:
Telephone 843-853-2070
Fax 843-853-0044
E-mail sales@arcadiapublishing.com
For customer service and orders:
Toll-free 1-888-313-2665

Visit us on the Internet at www.arcadiapublishing.com

To Pamela Berndt Arnold with gratitude.

The Jamestown, Westfield & Northwestern Railroad ran along the east side of the lake from 1913 to 1950 while the Chautauqua Traction Company serviced passengers on the opposite side from Jamestown to Mayville, including stations in Lakewood and at the main gate of the Chautauqua Institution. (Courtesy Sydney S. Baker.)

CONTENTS

PREFACE

"If we study the lives of those who founded the wilderness settlement that has become the city of Jamestown—those who lived and wrought here not only for their own good but for the generations that should follow; we shall discover that true nobility was here in abundant measure.

To inscribe upon enduring tablets, the records of their deeds, is to recognize the wealth of their civic bequest and the legacy of their devotion.

To stand upon the scenes that once they knew, and read what in the long ago transpired there widens the limits of our mental world, enriches our lives, and enlarges our faculty of sympathetic understanding.

The inscriptions upon these tablets are the outlines of a fascinating story."

—From the foreword of *A Guide to Jamestown Historical Tablets*
Arthur Wellington Anderson, Jamestown Centennial Historian, 1928

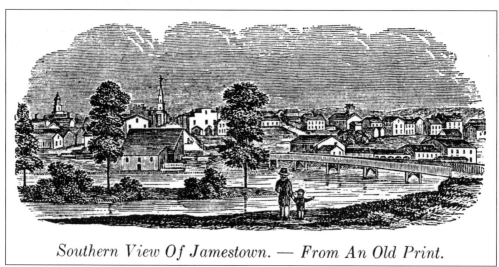

Southern View Of Jamestown. — From An Old Print.

This vintage postcard provides a panoramic view of industrial Jamestown, looking north of the Chadakoin River to the city's center. (Courtesy Kathleen Crocker.)

INTRODUCTION

Approximately 2,800 blue and gold permanent markers throughout New York State identify and commemorate historic sites. Begun in 1926 by the state education department, the New York State Historic Marker Program was designed to celebrate the American Revolution's sesquicentennial. The program continued to be funded by the state until 1939, when local historians and civic groups ensured the authenticity of sign locations and text. The cast-iron markers were erected to enlighten travelers and motorists unfamiliar with the history of neighboring towns and cities. According to the New York State Museum Services, these historic markers remain "a popular and enduring form of historic preservation and cultural education."

In accordance with the New York State Education Department, the Jamestown Centennial Commission of 1927 proposed establishing several permanent markers to celebrate the centennial of the incorporation of the village of Jamestown. City historian Arthur Wellington Anderson assisted the committee in the extensive research project.

In 1986, the Jamestown Centennial Celebration Historical Marker Committee, with assistance from the state, chose to perpetuate the tradition to celebrate the centennial of the city of Jamestown. Praising the earlier "history buffs [who] had the good sense to take note of some of those sites that marked the birth of the community," Jamestown's historian B. Dolores Thompson and her peers sought input from the general public to honor additional sites and citizens that noticeably impacted the city's growth. They then published a 48-page pamphlet, *Historic Marker Sites in City of Jamestown*, as a reference guide.

To narrow the focus of our book, several historic markers are scattered throughout the pages, indicated either by the sign or in the text. While the markers provide the data, it is the images and captions that enable readers to sample some of Jamestown's industrious citizens and the community they created.

—Kathleen Crocker and Jane Currie

ACKNOWLEDGMENTS

Foremost, we honor the dedicated members of the 1986 City of Jamestown Centennial Celebration Committee, who preserved the city's heritage by their efforts: B. Dolores Thompson, city historian and chairman; Norman P. Carlson; Harold G. Griffith; Daniel F. Lincoln; Pauline N. MarLett; Cornell E. Seaburg; and Jennie Vimmerstedt. The ex-officio members included Steven B. Carlson, mayor; and Russell E. Diethrick Jr., director of the Jamestown Parks, Recreation and Conservation Department. We are also indebted to the 1927 Centennial Commission members, especially William S. Bailey Jr., chairman, and Arthur Wellington Anderson, centennial historian.

For their continued patience and love, we thank Byron and Ed.

For their invaluable expertise and time, our sincere appreciation goes to Pamela Berndt Arnold, Peggy Snyder, Joan Fox, and Elisabeth Edwards. For research assistance, we heartily thank Sydney S. Baker, Cristie Herbst, Linda Carlson, Ellen Schwanekamp, James O'Brien, Catherine Way, Sharon Gollnitz, Billie Dibble, and Mary Jane Stahley.

We also commend the following for their generosity and contributions: Larry Arnold, Bob Bargar, Kathryn Benware, Jim Berry, Jim Butterfield, Dianne Calamunci, Brooke Colley, Robin Conklin, Fred Cusimano, Peter Flagg, Fran Galbato, Mark Hanson, Marty Herrick, Orrie Hoover, Andy Jochum, Rosanne Johanson, Scott Johnson, Terry Lind, Irene Lynch, Fred Mansfield, Janice Morrill, Jon O'Brian, Norm Owen, Greg Peterson, Lucille Phelps, Evelyn and Tony Raffa, Jonathan Schmitz, Candace Schupp, John Siggins, Mary Ann Smith, Leland Sperry, Mary Jane Stahley, Roy Swanson, Todd Tranum, Mary Weedon, and Ric Wyman.

We give special thanks to all image donors for their trust and interest; their names appear in parentheses beneath the borrowed photographs.

Kathleen Crocker (left) and Jane Currie proudly congratulate their friend Jim Roselle, who received a citation from the city of Jamestown on his 50th anniversary as a WJTN radio broadcaster. Along with his colleague Dennis Webster, Roselle also received the 2003 Chamber of Commerce's Pride of Jamestown award for helping Jamestown remain a viable and vibrant community. Faithful listeners tune in daily to "see" the voice of Jamestown on radio and enjoy Roselle's joie de vivre. (Courtesy Pamela Berndt Arnold.)

One

PIONEERS

Desirous of settling in a more temperate climate, a party of 29 people in canvas-covered wagons wended their way westward from Pittstown in Rensselaer County in eastern New York State bound for Tennessee. However, the families of William Sr., Jediah, Martin, Thomas, William Jr., and James Prendergast, along with William Bemus and others, were dissatisfied with their original destination.

Tennessee's loss was western New York's gain. En route, the travelers encountered William Peacock, the local land office clerk for the Holland Land Company, who encouraged them to settle in the Chautauqua Lake region, "the paradise of the New World."

Shortly after William Bemus became the first settler in the town of Ellery in 1805, the Prendergast clan purchased 3,337 acres on the west side of Chautauqua Lake near Mayville that extended to the Chautauqua Assembly grounds. While searching for horses that had wandered from the family's property, James Prendergast, one of 11 children, sighted his future home near the Chadakoin River, the outlet for Chautauqua Lake.

Awed by the potential of the waterpower and hill-covered hardwood forests, Prendergast immediately envisioned mills, factories and a transportation route conducive to the establishment of a lumbering and milling village. In 1811, upon his return from Pittstown with his bride, Mary, Prendergast was deeded 1,000 acres by his brother Martin. He purchased additional property and settled on the bank of the outlet with his wife. After his original home and sawmill were destroyed by fire, the Prendergasts relocated in the heart of the Rapids, so-named because of the outlet's swift current.

According to historian Gilbert W. Hazeltine, James Prendergast found not only his horses but "his fortune and fame," adding, "nobler men never settled a new country than those who subdued the wilderness at the rapids, and laid the foundations of all the blessings, social, civil and religious, which we, their children and successors, enjoy."

Lured by the area's wealth of natural resources, Prendergast and other pioneers harnessed the swift stream's waterpower to operate sawmills and gristmills and availed themselves of the forests for their lumbering enterprise, just as hunters and trappers took advantage of both for their livelihood.

By 1814, there were myriad pioneer shops and small businesses operating in the village itself and along the outlet to accommodate the community's needs. These included flour mills, cabinet and chair factories, cooperages, blacksmith shops, carriage and wagon shops, and hat shops. Axes, brooms, mirrors, pianos, pails, tubs, sashes, and doors were also fabricated.

Banding together for their mutual protection and advancement, the pioneers began to develop a sense of community. According to Mayor Eleazer Green, the pioneers "almost without exception, were well educated, of high character, and of excellent reputations in the communities whence they came. They were strong and vigorous physically and intellectually; they were industrious, persevering, determined. They came with a fixed purpose,—to transform the

wilderness into a community of comfortable Christian homes for themselves and their posterity."

Although the Jamestown manufacturing community was in its infancy, it would soon become well known for its furniture industry, an outgrowth of lumbering.

James Prendergast's gristmill and sawmill were two of the primary businesses in the Rapids. (Courtesy Sydney S. Baker.)

In 1810, shortly after he arrived from Pittstown with his wife, John Blowers built a log cabin near the outlet. The Blowers cabin, built under the direction of James Prendergast, was the first home in Jamestown, a historic marker site. The cabin became the nucleus of the small number of houses, mills, and shops in the Rapids region and housed one of the village's first taverns. (Courtesy Sydney S. Baker.)

The distinctive Van Velsor's triangle, mounted on the rooftop of the Allen Tavern at the corner of Main and Third Streets, summoned boarders to meals and served as a community fire bell. The Fenton Tavern, built in 1814, was one of the earliest gathering spots and, thus, a historic marker site, near the Keelboat Landing. Jacob Fenton, a Revolutionary War soldier and potter, relied on the patronage of keelboatmen, hunters, and fellow pioneers. (Courtesy Sydney S. Baker.)

Copy of map of Village of Jamestown
drawn by Thomas Disher while clerk in the
Store of Martin + Jedidiah Prendergast. on the
N.W. corner of Main and First St. From this
map Mr. Disher sold lots for Judge Prendergast.
by simply inserting the name of buyer on the
map of the lot which was not a hard
task as the lots were all the same size (50 x 120 ft.)
and the same price without reference to
surface or location ($50.)
 This store was a small frame building built
for Martin + Jedidiah P. merchants of may. of Wm. Forbes Wm Deland
and Phineas Almeter Jr. and was opened by
clerk, Thomas Disher, on Nov. 9th 1813. It was
a "General" Store and much "Mongahela" whiskey
was sold at $2.00 per. gal. No lots were
sold before 1815.

Although they never lived in Jamestown, Mayville merchants Martin and Jediah Prendergast, brothers of Jamestown's founder James, operated a small one-story frame store on the northwest corner of Main and First Streets, a historic marker site. According to this handwritten note found in Westfield resident Mattie Sullivan's scrapbook, the store was opened by clerk Thomas Disher, Prendergast's boarder, on November 9, 1813. Beaver, otter, deer, wolf, and musk skins brought into the store were shipped south on keelboats. Jamestown's first store also sold dry goods, groceries, hardware, and as the note indicated, "much 'Mongahela' whiskey . . . at $2 per gal." to the early settlers. After James Prendergast's nephew Thomas Bemus surveyed nearly 100 building lots in the new settlement in 1815, Disher drew a simple map of the uniform-sized 50-by 120-foot lots, all of which were owned by Judge Prendergast and sold for $50. The purchaser's name was recorded on the map, and the only copy was kept in the Prendergast general store for nearly 40 years. (Courtesy Kathleen Crocker.)

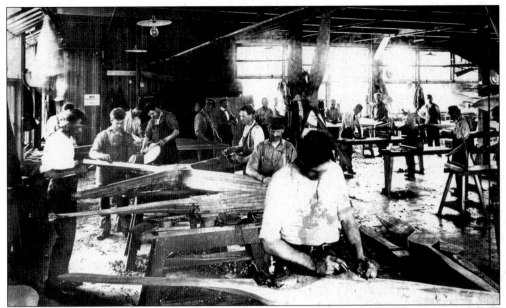

During World War I, craftsmen at the Jamestown Mantle Company aided the war effort. This photograph, attributed to Frank F. Leet, shows mahogany propellers being produced for a U.S. Navy flying boat that crossed the Atlantic in May 1919. In the early 1930s, this company, along with several other small furniture operations, was forced to close due to the Depression. (Courtesy *Post-Journal*, Jamestown.)

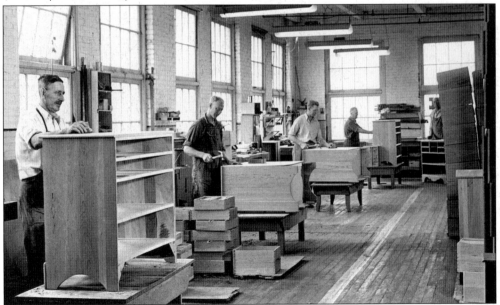

Atlas Furniture Company was incorporated in 1883. Its factory on the Erie Railroad line grew to be one of the largest in the industry, employing more than 250 persons. In 1941, it was purchased by Clyde Crawford, who initiated a unique state- and federal-approved training program for discharged World War II servicemen. Their apprenticeship for the Crawford Furniture Manufacturing Corporation was spent partly in the plant (above) and at Jamestown High School. (Courtesy Jamestown Manufacturing Association.)

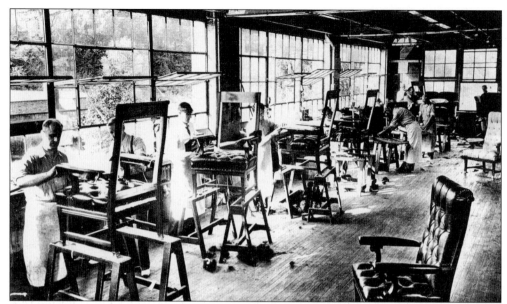

Sven Emil Peterson (front left) and Eric Pearson (in the background) were two of the nine master craftsmen working at the Jamestown-Royal Upholstery Company who, in 1935, custom made elegant leather chairs, specially ordered for the U.S. Supreme Court justices. Each classic handmade leather- and cloth-upholstered piece, whether ordered by Gov. Thomas E. Dewey, Gen. Douglas MacArthur, first lady Mamie Eisenhower, or less prominent individuals, was fashioned by a single craftsman. "One man, one job." (Courtesy Jamestown Royal Furniture Inc.)

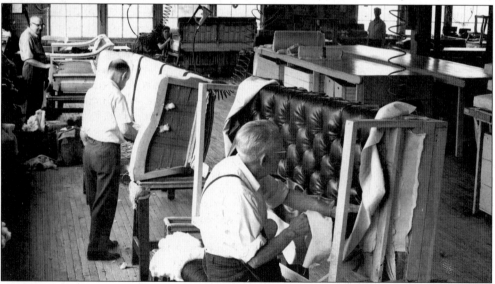

Jamestown Royal, located on Crescent Street near the Erie Railroad tracks, once the heart of the furniture industry, remains open despite its low volume. "Singly and silently," 25 to 30 talented tradesmen once worked there. Established in the late 1880s, Frederick Nelson bought the company in 1913 and partnered with Earl and Carl Hultquist in the 1920s. Since 1962, the Leslie Johnson family has managed the business. For nearly 20 years, Peter Johnson, the current owner, has purchased only the finest upholstery and leather for "the best made line in America." (Courtesy Jamestown Royal Furniture Inc.)

Three

TRANSPORTATION

Prior to the Civil War, canoes, keelboats, and flat-bottomed scows were the main modes of navigation in the county. Goods and supplies from the Chautauqua Lake region were transported to settlements from Pittsburgh southward along the Mississippi River as far as New Orleans via a system of rivers: the Chadakoin, Conewango, Allegheny, and Ohio.

Following the era of the stagecoach and horse and buggy, Jamestown's residents and others around the lake were dependent upon steamer service for food and supplies. The fleet of steamboats on Chautauqua Lake also provided the most satisfactory means of travel. The major steamers delivered passengers, personal belongings, freight, and mail on scheduled trips every day from railroad depots and various lakeside docks to work, hotels, and summer residences.

However, as with most towns, the advent of the railroad was the most significant contribution to the growth of Jamestown. On August 25, 1860, Jamestowners enthusiastically welcomed the Atlantic and Great Western Railroad, a small train carrying only a few invited guests. According to the *Jamestown Journal* of August 30, 1860, "the first iron horse that ever neighed in our town strode with majestic tread across the Main Street bridge . . . the eager multitude . . . thronged the avenues, vacant places, windows and house tops, to witness the first throb of this great artery of civilization in Southern Chautauqua." And, as part of the extensive Erie Railroad system having links to New York City to the east and Cleveland, Cincinnati, and St. Louis to the west, travel for business and pleasure became nearly limitless. The region's commercial, industrial, and economic development were practically ensured.

Members of the William Broadhead family, through personal commitment and entrepreneurship, controlled all the transportation around Chautauqua Lake: initially, the Jamestown Steamboat Company and the Jamestown Street Railway Company, and in 1922, also the Jamestown Motor Bus Transportation Company. Because of their vision, wisdom, and enormous financial investment in their own city, the entire region prospered. Mayor Emeritus Samuel A. Carlson candidly admitted that, "No two men contributed more to the development of the city and its program than 'Met' and 'Shel,' " an obvious reference to William Broadhead's sons, Almet Norval and Sheldon Brady Broadhead.

For further validation of that family's influence, Carlson added, "The streetcar [trolley] has played a great part in the community life, its social activities and in bringing the people together." Coupled with the speedier, more convenient and comfortable motorbus service, the two conveyances not only gave impetus to the region's development but also transported millions of passengers annually to a variety of destinations. During normal service, 14 trolley cars ran on lines totaling a distance of approximately 18 miles. Similarly, 12 buses covered nearly 26 miles throughout the Jamestown city limits, with additional runs to Greenhurst and Lakewood. During peak travel times, extra cars and buses were enlisted to accommodate passengers' needs.

Automobiles inevitably caused the demise of trolleys. To mark the end of the trolley era, the

last passengers received special commemorative tokens and several of the cars' light bulbs mysteriously disappeared and now adorn backyards throughout the city. Outmoded, the trolley cars met the same fate as the steamboats; both were scrapped and vanished from city life. In order to resurrect a bit of the past, trolley car No. 93 was recently retrieved from its wooded burial grounds near Dewittville. It is hoped that donations to the Trolley 93 Fund will be sufficient to have the relic restored and permanently housed as a testament to earlier days in the Chautauqua Lake region.

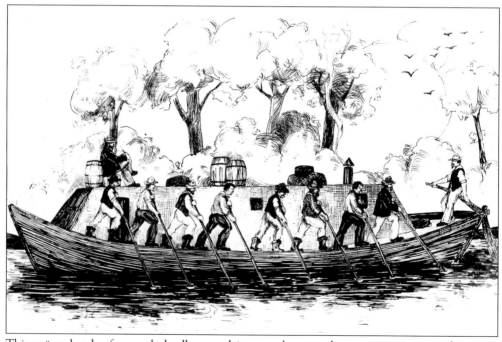

This naïve sketch of an early keelboat and its crew by an unknown artist is a popular image frequently found in Chautauqua County history publications. (Courtesy *Post-Journal*, Jamestown.)

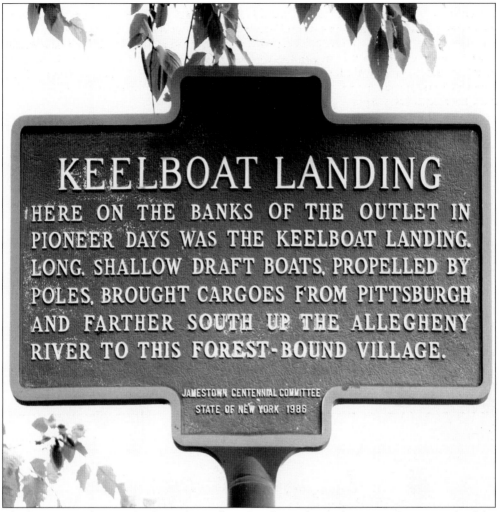

KEELBOAT LANDING

HERE ON THE BANKS OF THE OUTLET IN PIONEER DAYS WAS THE KEELBOAT LANDING. LONG, SHALLOW DRAFT BOATS, PROPELLED BY POLES, BROUGHT CARGOES FROM PITTSBURGH AND FARTHER SOUTH UP THE ALLEGHENY RIVER TO THIS FOREST-BOUND VILLAGE.

JAMESTOWN CENTENNIAL COMMITTEE
STATE OF NEW YORK 1986

The historic marker site for the early Keelboat Landing is located on Main Street, south of the railroad viaduct on the bank of the Chadakoin River. Prior to the horse boats of 1824 and the steamboats on Chautauqua Lake, long and narrow keelboats, Durham boats, and large canoes transported goods from Jamestown down the Mississippi River to New Orleans, Louisiana. Headquartered in Mayville, the motley keelboat crews—reputed to be boisterous roughnecks and drunkards, eight men on each side of the boat—maneuvered their crafts to the Jamestown boat landing by walking or poling them along the shore, battling the current. Settlements along the Allegheny and Ohio Rivers depended upon these men and crafts for sustenance and livelihood, as did the villagers in the early Jamestown settlement. Capable of holding several tons of weight, keelboats carried furs, sugar maple, and salts south. Provisions such as flour, bacon, salt, molasses, dried fruits, tobacco, whiskey, nails, iron, glass, and supplies for farms and sawmills were returned north to the Chautauqua region from Pittsburgh via the Allegheny and Conewango Rivers. When the keelboats were overloaded, lumber was also shipped south on flatboats. (Courtesy Jane Currie.)

The *J. A. Burch* was one of four steamboats built in 1880. Its handsome filigree and 154-foot length made the former *Hiawatha* easy to distinguish. Built at Phillips Mills near Bemus Point, the boat was renamed the *City of Chicago* in 1892. Second in size to the *Jamestown* (right), it

This vintage postcard provides a view of the boat landing with a noticeable lack of activity. Normally, a large assemblage of passengers, luggage, and freight would be visible on the wharf. Note the Fairmount Avenue bridge (background), the Riverside Hotel (lower left, with "L" on the top floor), and the Jamestown Table Company (center, near the moored steamer). (Courtesy Chet and Pat Crandall.)

26

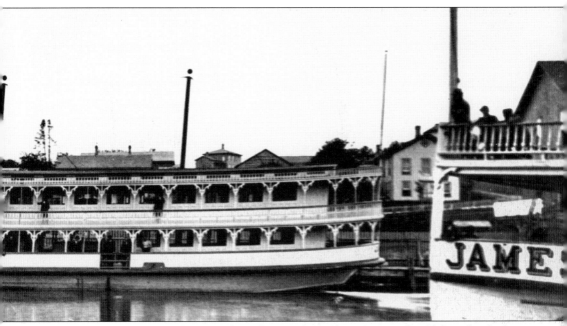

became an excursion boat and operated until it was burned in 1903 at the Clifton dry docks. (Courtesy Jane Currie.)

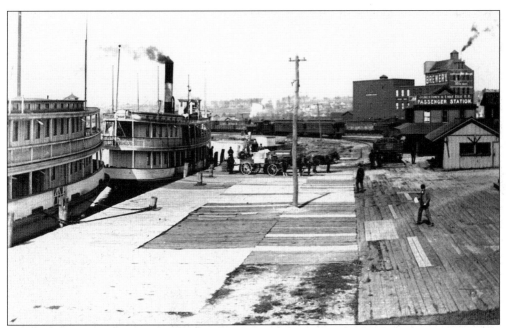

The steamboat landing on the banks of the outlet of the Chadakoin River was a historic marker site and the southern terminus, about eight blocks from the center of the city. Travelers could either walk or ride trolleys the short distance to make connections at the adjacent railroad depot. Steamers made daily round trips to connect with trains at Mayville, Lakewood, and Jamestown, the only transfer stations around Chautauqua Lake. (Courtesy Sydney S. Baker.)

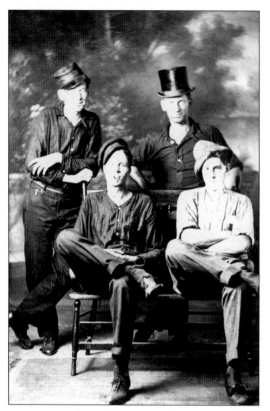

The *City of Cincinnati*, built in 1882 by the Burrough brothers, was considered one of the speediest on the lake. Members of the crew in 1908, from left to right, are: (seated) Andy Carlson and Garfield Fors; (standing) Douglas McKay and Arthur Carlson. These men were probably aboard when, on August 6 of that year, the steamer hit a submerged piling at the Chautauqua Assembly pier and nearly sank. (Courtesy Chautauqua Township Historical Society.)

"Gar" Fors and the younger Melvin Cox stand beside the pilothouse on the *City of Cincinnati* deck. Fors was the sleek steamboat's fireman, and Cox was referred to as the "pie boy" in Fors's scrapbook. Fors continued in the transportation industry, working on the Jamestown, Chautauqua and Lake Erie Railroad and, later, its successor, the Jamestown, Westfield and Northwestern electric trolley. (Courtesy Chautauqua Township Historical Society.)

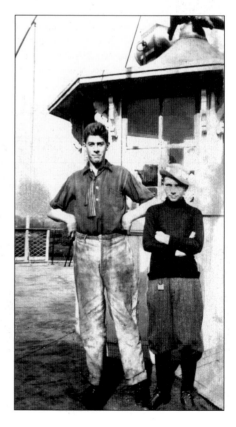

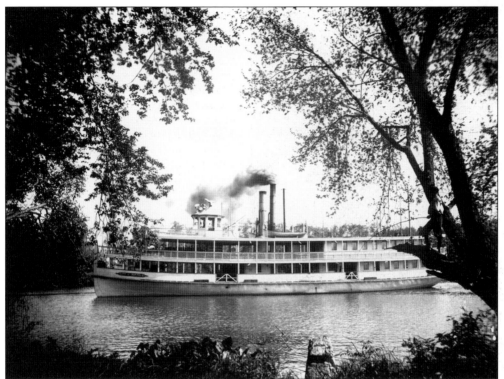

The *City of Buffalo* was built in Jamestown in 1890. It operated as part of the Great White Fleet for nearly 40 years. Despite this tranquil image, the steamboat was deliberately burned at Celoron's dock during the 1929 Labor Day celebration. *Chautauqua Lake Steamboats* referred to its demise as "another fiery spectacle." (Courtesy Sydney S. Baker.)

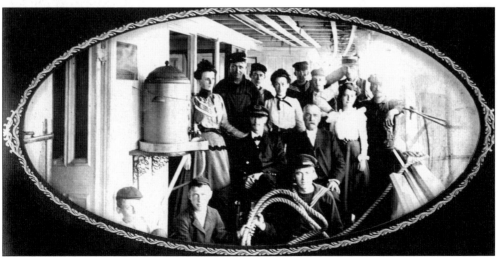

In addition to the essential skilled services of the pilot, captain, and fireman, a steamer's crew might also warrant the assistance of others. Like modern office workers standing around the water cooler, women, men, boys, and girls of various ages cluster near the water container to pose for this photograph. (Courtesy Sydney S. Baker.)

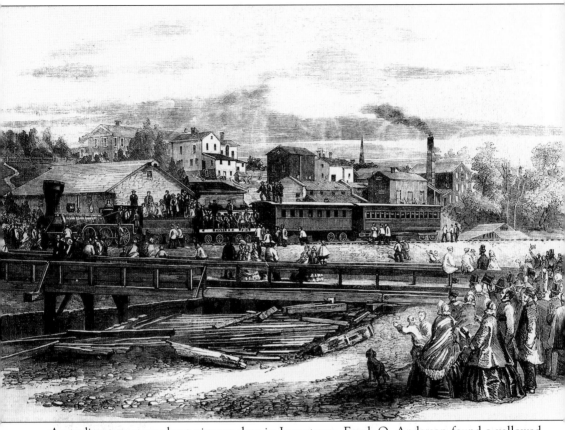

According to a story about pioneer days in Jamestown, Frank O. Anderson found a yellowed and brittle piece of the *London, England, Illustrated News* of 1860 in an old trunk. Curious about this engraving of Jamestown's first railroad, Anderson learned from the original article that the Atlantic and Great Western Railroad was financed by British capital. Although the train was in America, the newspaper editors published the image to document the result of their countrymen's investment. Apparently, Salamanca—the most eastern point on the Atlantic and Great Western Railroad—was named in honor of the agent sent to England to seek funding for the railroad's construction. In addition to the welcoming throng, it is evident that nearly 150 years ago, Main Street near today's overhead railroad viaduct, the historic marker site, resembled a mere path. (Courtesy Sydney S. Baker.)

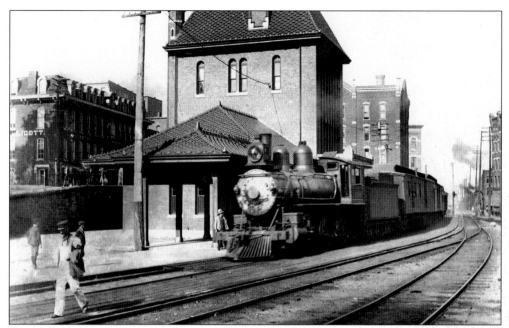

This second Erie Railroad passenger station, identified by its brick roof, central tower, and extensive wings, was the most important station between Elmira and Chicago on the Erie line and on the branch line to Buffalo. Recollections by Daniel Moynihan, a freight handler in the early 1900s, are found on the Western New York Railroad archive website: "We used to put planks from the cars to the depot platform and carry or roll the freight across. When a train came along we had to pick up our planks and knock off work until it passed." (Courtesy Edward Schaefer.)

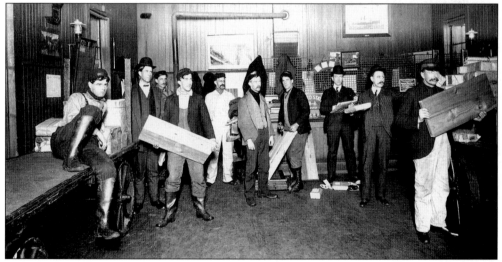

Pictured c. 1900, Harry W. Boyd (far left) and Ralph A. Noble (right foreground) worked for the Wells Fargo Express Company, located inside the two-story wooden Erie Railroad passenger station, built by the Atlantic and Great Western Railway in 1865. According to the *Jamestown Journal* of August 24, 1860, the site, on West Second Street at the foot of Cherry Street, was chosen primarily for the convenience of the "traveling community, . . . business will now be distributed through Main Street and its natural connections, and all the places will grow by impetus." (Courtesy Mary Jane Stahley.)

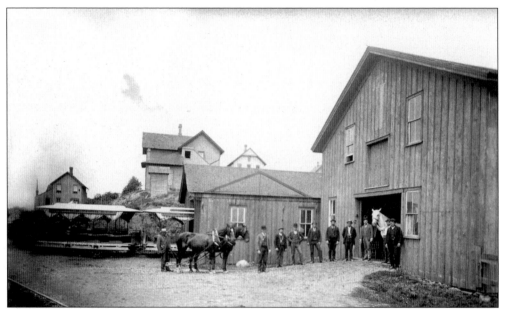

This old horsecar station *c.* 1891 was the terminus for the horse-drawn trolleys. When the line was electrified, the Jamestown Street Railway Company's carbarns near the Third Street bridge were modernized, as seen on the bottom of the next page. On December 22, 1928, four trolley cars and four automobiles housed inside were destroyed in a fire that apparently started in the paint shop. In addition, several nearby neighbors lost their living quarters. (Courtesy Chautauqua County Historical Society.)

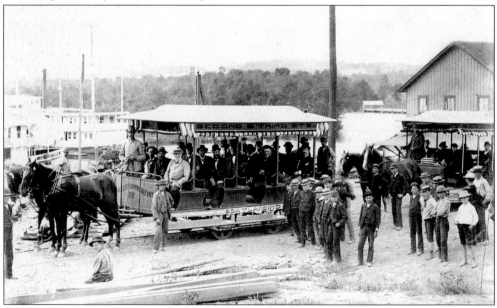

On June 19, 1884, the Jamestown Street Railway's first run via the open horsecar conveyed the company's directors and special guests, including former governor Reuben E. Fenton, from the boat landing to the Sherman House, the south side loop. All cars began and ended their runs at the centrally located Sherman House waiting room, at the corner of West Third and Cherry Streets. (Courtesy Sydney S. Baker.)

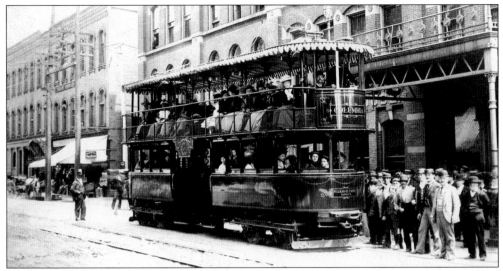

The double-decker trolley *Columbia*, named to honor the Columbia Exposition in Chicago, is stationed in front of the Sherman House *c.* 1893. It was used primarily to shuttle up to 50 passengers, plus hangers-on, to Celoron Park. The most profitable venture of the Jamestown Street Railway Company, it boasted seats for the ladies and outward-facing upper-deck benches. (Courtesy Lind Funeral Home Inc.)

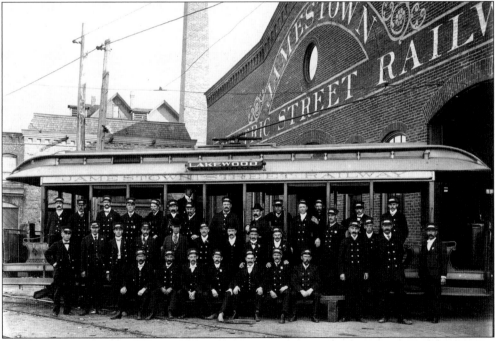

Travel over rough, unpaved streets became much easier in 1884 with the introduction of the horse-drawn trolleys. The first electric-powered trolley car began service in 1891 and continued until January 1938. The numbered cars traversed different areas within the city limits, including the Willard Street incline; other lines extended to Lakeview Cemetery, Falconer, Celoron, and Ashville. These conductors are standing in front of a Jamestown-Lakewood trolley at the Third Street carbarns. (Courtesy *Post-Journal*, Jamestown.)

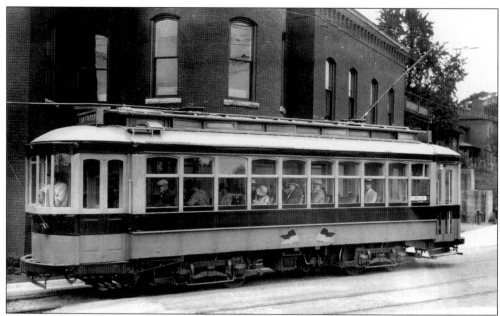

Because the windows could be raised all the way up and stored under the roof section, the red and tan Yonkers Railway trolley car, shown c. 1926, was in service year-round. Because of their schedule and affordability, the trolleys became the favorite mode of public transportation. The trolley car No. 93 restoration project reminds residents that whether they rode one, worked on one, or heard stories about one, the trolley is worth remembering and saving. (Courtesy Roy Erickson.)

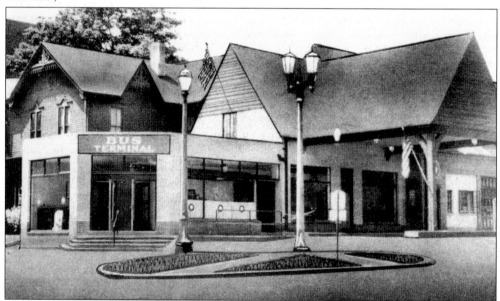

A small fleet of buses, operating in addition to the trolley cars for several years, carted passengers to Falconer, Celoron, and Lakewood. When buses and automobiles came into vogue, the trolley cars were scrapped. With their loss, a vital part of Jamestown's history vanished. Many people also remember and miss this downtown bus terminal, which once provided scheduled service for travelers between Jamestown and Buffalo. (Courtesy Edward Schaefer.)

Four

INDUSTRIES

Lumbering was the first lucrative industry in Jamestown's early settlement. With their monetary gains, independent furniture makers often invested in other endeavors, many of which were furniture related. Small furniture factories flourished throughout the 1800s and were soon joined by textile operations, which furthered the area's growth and prosperity.

Despite the responsibly managed furniture and textile operations, the key to the region's successful economy was diversification. As far back as 1894, county historian Obed Edson reported that Jamestown "has always been noted for its diversity of products, and this is the chief reason for its prosperity. . . . No manufacturing city of America has so many varying products for the population and capital invested, nor is there one where individual enterprise does so much of the business."

Advertisements for Jamestown industries listed just a few products made by the city's work force: "weaving of cloth, making yarns, radiators for autos, mail boxes, washing machines, steel desks, steel letter files, bank fixtures, bronze and steel revolving doors, steel windows, parts for autos, plants that make steel bunks, doors and other equipment for ships, destroyers, etc., including two large ball bearing plants." In fact, records show that at one time more than 400 manufacturing concerns produced 60 or more lines of goods.

Some interesting statistics follow: in 1900, with a population of 25,000, one out of every four residents was employed in a local factory; the 1910 census indicates that most city residents were employed in the manufacturing and mechanical industries dealing with iron, steel, lumber, furniture, and textiles. In 1914, newspaperman A. J. Lannes remarked that "Jamestown exhibits industrial supremacy in an advanced degree over most cities its size, in the number of factories and capital invested as well as in the value of its factory products and in the number of wage-earners."

According to a 1957 economic survey, almost half of Jamestown's employees worked in basic industries: approximately 3,000 in metal furniture; 2,900 in machine factories such as ball bearings; 2,750 in fabricated metals such as hardware, metal doors, and screw machines; 1,425 in wood furniture; and 750 in textiles.

Scrapbooks preserved in the Jamestown Manufacturing Association archives contain many fascinating articles about the role played by local companies and their employees during World War II. Industrialist Ralph Norquist, for example, devised an assembly procedure for packing boxes to hold incendiary bombs sent to both the Pacific and European theaters of war. The Blackstone Company produced radiators for combat trucks, cars, and jeeps, and Art Metal employees were honored by the War Department for their distinguished service to America. More than 90 percent of workers purchased war bonds through payroll deduction and, in return, received minuteman flags to proudly display at the plants.

Although innumerable industries succumbed to competition from cheap labor in the South, many seasoned second- and third-generation family members currently manage local industries

and continue to take pride in their quality products, which are marketed throughout the United States and abroad. Although on a smaller scale than in years past, Jamestown's name remains synonymous with a skilled work force and superior goods.

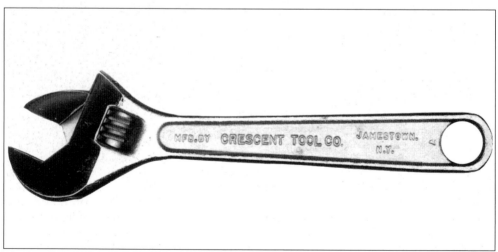

The Crescent wrench, only one of many worldwide-known products manufactured in Jamestown, was supposedly based on a Swedish production model brought to Jamestown in the tool kit of an immigrant craftsman. (Courtesy Jamestown Manufacturing Association.)

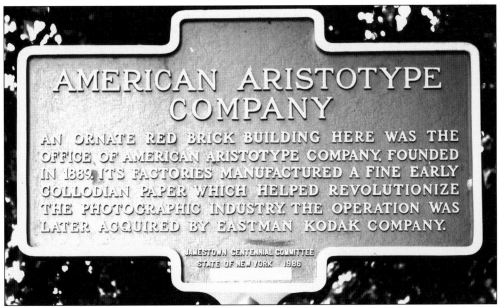

AMERICAN ARISTOTYPE COMPANY

AN ORNATE RED BRICK BUILDING HERE WAS THE OFFICE OF AMERICAN ARISTOTYPE COMPANY, FOUNDED IN 1889. ITS FACTORIES MANUFACTURED A FINE EARLY COLLODIAN PAPER WHICH HELPED REVOLUTIONIZE THE PHOTOGRAPHIC INDUSTRY. THE OPERATION WAS LATER ACQUIRED BY EASTMAN KODAK COMPANY.

JAMESTOWN CENTENNIAL COMMITTEE
STATE OF NEW YORK 1986

Porter Sheldon and Charles S. Abbott developed a novel industry in Jamestown in 1899. The first sensitized photographic paper in the United States was produced in their factory, which covered three city blocks near the present Heritage Park Nursing Facility, on Prather Avenue and Prospect Street, the historic marker site. Previously imported, their unique paper invention helped to destroy the foreign market and brought acclaim to Jamestown. Purchased by the Eastman Kodak Company, the operation relocated to Rochester in 1920. (Courtesy Jane Currie.)

In his 1941 Chautauqua County Historical Society address, John M. Cushman owned that "brickmaking is one of the oldest of human endeavors." The Jamestown Shale Paving and Brick Company, owned by Almet Broadhead, was perhaps the best known; it produced the hardest and most durable of brick from shale accessed from clay banks along the Chadakoin River. In addition to the hundreds of miles of sidewalks, nearly every foot of pavement laid in the city limits originated from local stone quarries. These bricks are also evident in Lakeview Cemetery's surrounding wall (above). (Courtesy *Post-Journal*, Jamestown.)

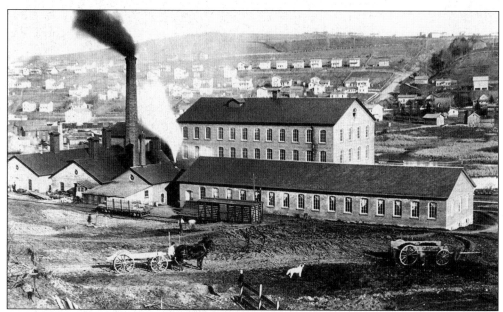

BROADHEAD ENTERPRISES

HERE WAS THE HOME OF WILLIAM BROADHEAD, INDUS-
TRIAL PIONEER, FOUNDER IN 1875 OF BROADHEAD
WORSTED MILLS. HIS SONS, ALMET N. AND SHELDON B.,
CONTINUED THE TEXTILE OPERATIONS, MEANWHILE
DEVELOPING CITY AND REGIONAL TROLLEY AND STEAM-
BOAT LINES, AMUSEMENT PARKS, COMMERCIAL ROSE
GARDENS, AND BRICK MANUFACTURING.

JAMESTOWN CENTENNIAL COMMITTEE
STATE OF NEW YORK 1986

Lucy Broadhead in 1990 wrote to "Candy" that her grandfather William Broadhead (1819–1910) was "commissioned by William Hall and others to go back to Yorkshire [England] and arrange for the purchase of second-hand machinery and the employment of key textile workers in order to start a textile mill in Jamestown." According to editor Butler F. Dilley, the Harrison Street plant, the historic marker site, became "the largest merchant tailoring establishment in Jamestown and the surrounding country," a major part of the Broadhead Enterprises, another historic marker site, located on the South Main Street family estate, now Wellman Brothers. (Courtesy Jane Currie.)

Meanwhile, William Hall (1793–1880) founded the Jamestown Worsted Mills, another thriving enterprise. By 1861, the mill was spread out into six buildings, with more than 700 employees, including carders, weavers, and spinners mainly from England. In 1873, William Broadhead and Hall formed a partnership with Joseph Turner to establish this alpaca mill, "the first mill on the Bradford [railroad] system west of Philadelphia to perform all stages of production from raw wool to finished cloth." (Courtesy Edward Schaefer.)

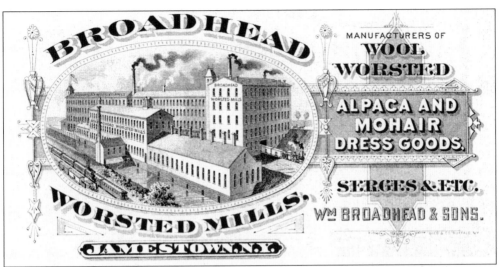

In 1875, William Broadhead left his original partners to join his sons Shelden B. and Almet N. in another mill venture. The Broadhead Worsted Mills, consisting of several large buildings on First Street, manufactured worsted suiting and fine dress goods. Hundreds of employees undertook all tasks from the initial wool washing to the finished goods. Until 1925, when both Broadhead sons died, the family's half-century of textile operations prospered. Along with the city's furniture industry, the mills were an integral part of local life. (Courtesy Edward Schaefer.)

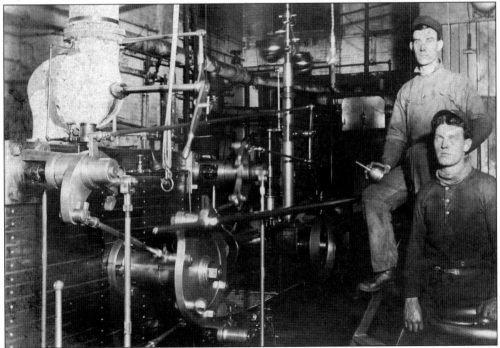

Established in 1888, the Empire Worsted Mills occupied over five acres on Water Street. Combing, drawing, spinning, warp dressing, wool sorting, wool washing, and dyeing were all done on site by more than 200 employees. Emmett Morrison (front right) is seen at work in 1905. The largest textile manufacturer's retail trade encompassed the entire country. (Courtesy Neil family.)

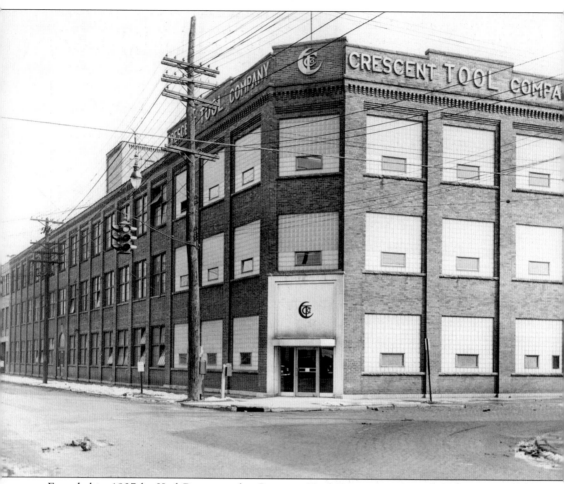

Founded in 1907 by Karl Peterson, the Crescent Tool Company, "one of the crown jewels of Jamestown's industry," consisted of nine connected buildings along the Chadakoin River and was one of the world's largest manufacturers of hand tools, including the famous wrench, pliers, screwdrivers, hacksaws, tinsnips, punches, and chisels. Rumor has it that Adm. Richard E. Byrd included a Crescent wrench among his supplies during his first voyage to Antarctica. Another successful operation was the Watson Manufacturing Company, begun in 1887, which first produced farm equipment. Founder H. W. Watson was succeeded as president by Donald P. Braley, whose daughter vividly remembers the company's motto "The Fly Outside" that was used to promote Watson window screens. Watson's designed and manufactured odd-sized, odd-shaped metal furniture and a stainless steel galley for the atomic submarine *Nautilus,* as well as equipment for the interior of Bell Aircraft planes built in nearby Niagara Falls. Myriad metal products were shipped throughout the world. (Courtesy Jamestown Manufacturing Association.)

William Blackstone invented the first boxlike tub washing machine in 1899. Operating under the management of Oscar Lenna and his sons, the Blackstone Manufacturing Company produced a hand-operated washing machine with a steel-hooped tub and a "milk stool" dasher for agitating the clothes. More advanced timesaving products, including the first fully automatic washers, gas and electric dryers, and coin-operated laundry machines, were marketed throughout the world from the Allen Street plant. (Courtesy Jamestown Manufacturing Association.)

The Vandergrift Rotary Washer

BLACKSTONE PATENTS.

APRIL 19, 1892, AND SEPTEMBER 26, 1899.

A light running and perfect Washer; works both ways, backwards and forwards.

The Washer closes tight, preventing the escape of foul steam, and retains the heat in water. It is not a mechanical luxury but a household necessity.

Any Woman can operate it with ease. It washes cleaner, better and with less injury to the clothes than when rubbed to pieces on a washboard.

Used in all parts of the world. Hundreds in use in Jamestown and vicinity. If not for sale by your dealer, ask us for price.

Manufactured by

THE VANDERGRIFT MANUFACTURING COMPANY,

Jamestown, New York, U. S. A.

GEORGE V. BLACKSTONE, Prest. WILLIAM A. BLACKSTONE, Treas.

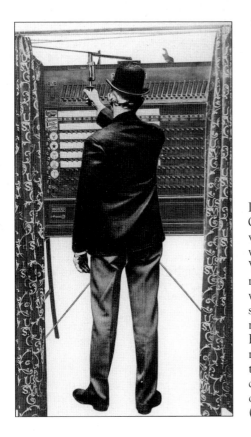

In 1896, the United States Voting Machine Company was formed in Jamestown. When voting machines became mandatory, 75 percent were built and sold by the renamed Automatic Voting Machine Corporation. Considered "the most modern and reliable Election System in the world," 100,000 AVM machines were used in 39 states in 1963. Sequoia Voting Machines tested a more modern version locally to comply with the Help America Vote Act requirements, federally mandated because of the Florida debacle during the 2000 U.S. presidential election. This voter is demonstrating the mechanical lever machine, once essential to the American election process. (Courtesy *Post-Journal*, Jamestown.)

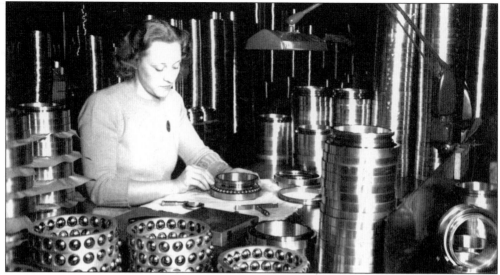

In 1905, Frederick W. Gurney, founder of the Gurney Ball Bearing Company, was a pioneer in the design and production of ball and roller bearings. The Marlin Rockwell Corporation (MRC), formed in 1924, became the first Jamestown company listed on the New York Stock Exchange and one of the country's largest industrial employers. MRC manufactured precision bearings ordered for use in both U.S. spacecraft and atomic-powered submarines. The globally recognized corporation will soon celebrate its centennial. (Courtesy Jamestown Manufacturing Association.)

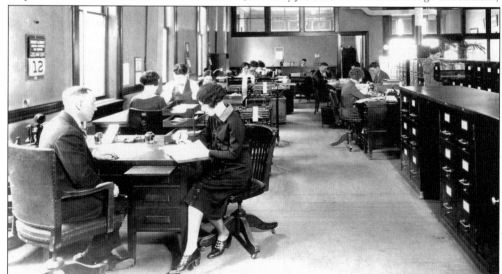

Established in 1888, the Fenton Metallic Manufacturing Company designed and produced metal office equipment and furniture, metallic vaults, and the Fenton bicycle. When its name changed to the Art Metal Construction Company, under Arthur C. Wade's leadership, it became one of the world's largest producers of metal office furniture, advertising more than 1,000 items in its catalog. Sitting near the file cabinets c. 1920, with the marcelled hair, Hildur Anderson Morgan worked in the company's office. The steel library shelving manufactured at the company's Jones and Gifford Avenue plant, the historic marker site, has been installed in facilities nationwide. Even the Russian warship *Variag* boasted Art Metal equipment produced in distant Jamestown. (Courtesy Marilyn Johnson.)

Five

CIVIC PRIDE

The earliest settlers in Jamestown were superb models for their progeny. In 1886, Judge Richard P. Marvin, an avid public servant and responsible citizen, proudly told an audience that "Jamestown possessed an industrious, enterprising and intelligent population. There were few idlers among us." Despite their varied occupations, the city fathers were exceptionally progressive and unhesitatingly supportive of new enterprises to better their community. Jamestown's industrial and business pioneers were, on the whole, visionaries to whom future generations have been indebted.

Seeking economic stability, people of several different ethnic groups were attracted to Jamestown and the Chautauqua Lake region. These diverse cultures obviously impacted Jamestown's education, religion, and social life.

For the sake of brevity, only a concise composite of Jamestown's inhabitants follows. The greatest influx of the Swedish immigrants was in the last half of the 19th century. Although they made their most significant contribution to Jamestown's furniture industry, their honest and intense work ethic led them to become blacksmiths, clothiers, butchers, housekeepers, and journalists.

Historian A. W. Anderson noted that although the Scandinavians were "poor in worldly goods . . . they laid the foundation for the prosperity of their descendants." This held true for other immigrant groups as well. Next was the arrival of the Englishmen, many of whom were uprooted from the eastern states in order to work in the familiar textile industry and business world.

The population began to explode in the 1850s. More than 100 African Americans settled in Jamestown, while many Irish staked roots in east Jamestown's Dexterville area, located near the Erie Railroad where they worked as laborers. The Germans and Danes worked in the furniture industry, textile mills, and ice-harvesting business and on the lake steamboats.

In 1887, Italians augmented the local work force as tailors, dressmakers, stonemasons, bricklayers, barbers, musicians, and grocers and also entered the fields of medicine and law. Albanians, who formed their first North American community in Jamestown in 1903, were preceded by both the Jews and the Greeks, who arrived in the mid- to late 1880s. Because of this vast immigration, by 1910, over half of the population of Chautauqua County was of foreign birth or parentage; the integration and assimilation process had begun.

In 1943, Mayor Emeritus Samuel A. Carlson lavished this praise on his hometown: the city "is a place in which we find the highest spiritual and social influence. A place in which to rear men and women of the noblest type of citizenship. The real standard by which a city should be judged is, not the magnitude of its population, or its bank balance, or its costly structures, or its tax rates, but the joy, comfort and value which the average man and woman gets out of life. That is the true criterion. Measured by that standard, Jamestown stands among the foremost of American cities with a future full of promises."

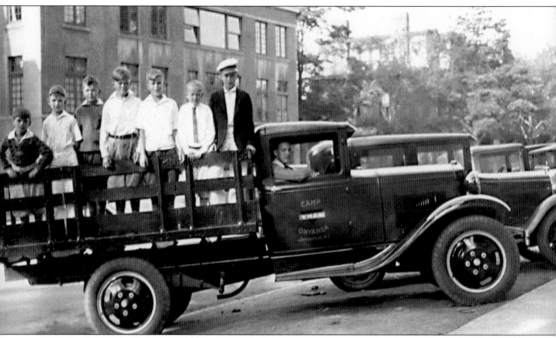

These boys, in the rear of Camp Onyahsa's truck, were driven back and forth from the downtown Jamestown YMCA to their lakeside facility in Dewittville. In later years, girls, too, attended the summer camp, whose mission remains "the development of spirit, mind, body and community." (Courtesy YMCA Camp Onyahsa, Jamestown.)

James Prendergast (1848–1879), the city founder's grandson and namesake, intended to devote his Prendergast Building "to the establishing and maintaining of a free public circulating and reference library in the city of Jamestown." On January 30, 1880, his parents deeded the building, an entire city block (250 by 256 feet), to the Jamestown Public Library Association. The interest from the building at Main and Third Streets was invested, and by 1898, the maintenance of the library and art gallery was paid by the endowment. (Courtesy *Post-Journal*, Jamestown.)

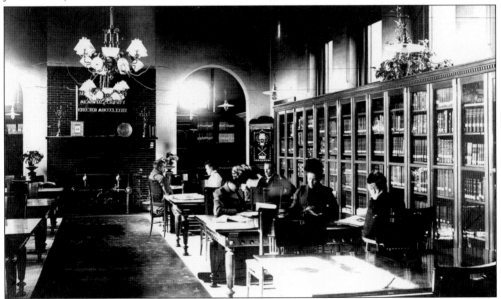

Mary A. Prendergast further supported her deceased son's wishes in her own will. She bequeathed additional finances for the maintenance of the library grounds and for the purchase of books. She also desired that the compact art gallery contain oil paintings and other worthy works of art. The library's Fireplace Room, where these readers and researchers are engrossed, still contains family portraits and paintings that once hung in the Prendergast residence. (Courtesy James Prendergast Library Association.)

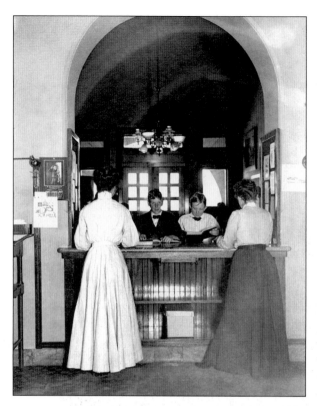

The James Prendergast Library was prudently managed by only three librarians during its first four decades. In 1901, members of the library school at the Chautauqua Institution "made 11 trips to Jamestown to study, using the [Prendergast] library as a laboratory, working out the ideas practically that they were taught theoretically" in their classes at Chautauqua. Today, the James Prendergast Library ranks among the top 100 public libraries in the United States and, with its competent and dedicated staff, is recognized as "part of a powerful statewide online library network with vast electronic resources." (Courtesy James Prendergast Library Association.)

In July 1898, the 20th annual American Library Association (ALA) meeting was held at Lakewood-on-Chautauqua, a radical departure from the previous major city sites. More than 400 librarians convened at the posh Waldemere and Kent Hotels. Melvil Dewey, the director of the New York State Library System, involved the group in a Library Day at the Chautauqua Assembly grounds, where cofounder Bishop Vincent introduced the visitors to the Chautauqua idea of education. Scheduled pleasure trips included steamboat excursions, trolley rides, picnics, a Celoron theater party, and a tour of local industries. (Courtesy James Prendergast Library Association.)

46

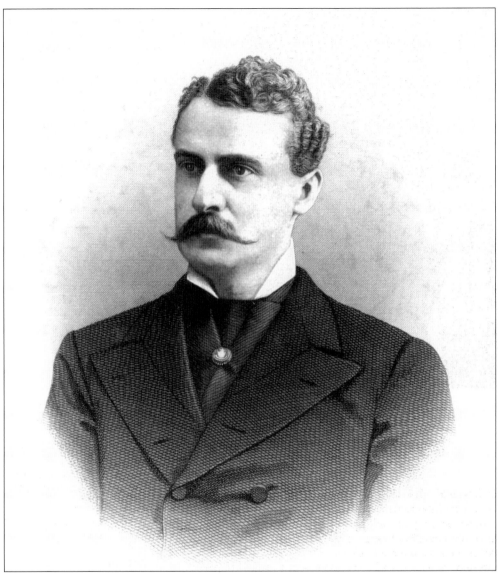

James Prendergast, son of Alexander T. and Mary A. Prendergast, was a graduate of Columbia College Law School. He returned home to become a partner in the Green, Prendergast and Benedict law firm but died at a relatively young age. In a memorial tribute, the Jamestown Board of Trade noted that he "took up and continued the work of building up Jamestown in moral and material prosperity—a work which had come to him in natural succession from his worthy grandfather and father. . . . [He was] gifted with practical good sense and sagacity, he perceived the hopeful possibilities of our city's future, and aided many in material ways in the substantial growth and prosperity of Jamestown." (Courtesy James Prendergast Library Association.)

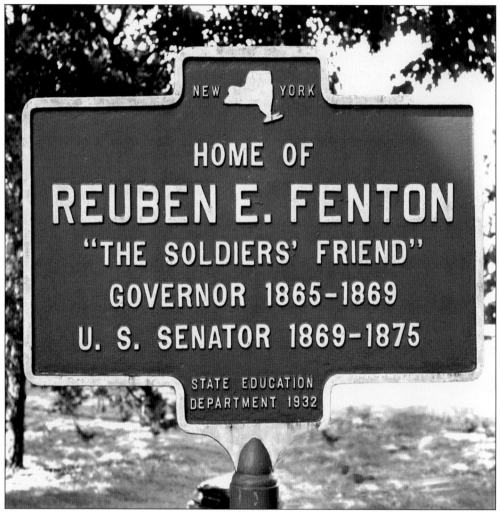

Amassing his fortune in the lumber business, Reuben E. Fenton (1819–1885) served in the state legislature and twice as governor, primarily during the administration of Abraham Lincoln, to whom he credited his gubernatorial candidacy. As governor, he executed reforms that raised the standards for New York State teachers and also signed a bill in 1867 that abolished tuition for New York State public schools. One of the founders of the Republican party, Fenton was privileged to chair the first party convention in New York in 1855. He also founded and served as director of the First National Bank of Jamestown and aided the economy of New York State following the Civil War. He was nicknamed "the Soldiers' Friend" because of his special concern for their welfare. He not only made personal visits to army camps but also helped pass the Soldiers' Pension Bill, which provided financial support for men disabled in the line of duty. (Courtesy Jane Currie.)

Reuben E. Fenton was memorialized in Albany on April 27, 1887. His distinguished public and political service and his life and character were praised. An "exalted patriot" and an "honored statesman," Fenton received "cordial confidence from workingmen fresh from the forge, or merchants in their parlors and counting-houses." The Honorable Chauncey M. Depew eulogized that "Many of New York's sons have risen to distinction, but none have embodied in their character so many qualities that led to success." (Courtesy Chautauqua County Historical Society.)

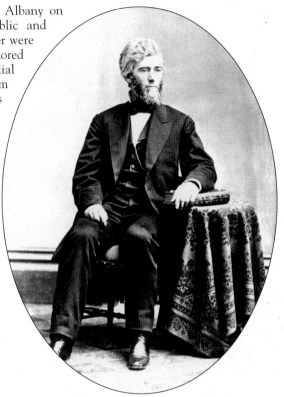

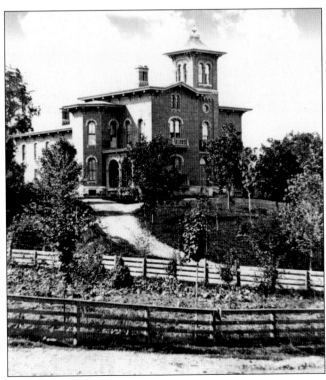

Following his political career, Fenton returned to Jamestown to reside in this stately red brick Italian-style villa, a historic marker site, designed by local architect Aaron Hall. Once the national headquarters of the Grand Army of the Republic and the meeting place for various veterans' organizations, the mansion has housed the Fenton Museum and History Center since 1964. Situated on a hill overlooking the city, the mansion was added to the National Register of Historic Places in the early 1970s. (Courtesy *Post-Journal*, Jamestown.)

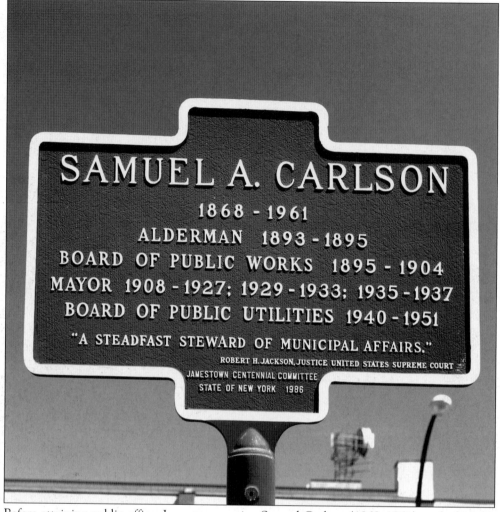

SAMUEL A. CARLSON
1868 - 1961
ALDERMAN 1893 - 1895
BOARD OF PUBLIC WORKS 1895 - 1904
MAYOR 1908 - 1927; 1929 - 1933; 1935 - 1937
BOARD OF PUBLIC UTILITIES 1940 - 1951
"A STEADFAST STEWARD OF MUNICIPAL AFFAIRS."
ROBERT H. JACKSON, JUSTICE UNITED STATES SUPREME COURT
JAMESTOWN CENTENNIAL COMMITTEE
STATE OF NEW YORK 1986

Before attaining public office, Jamestown native Samuel Carlson (1868–1961) worked in the worsted mills and at Breed Furniture Company, owned a small furniture factory, and ran *Vart Land*, a weekly Swedish newspaper. Elected mayor for the first time in 1908, he served in that capacity for 12 terms, or 26 years. This historic marker site on city hall's Tracy Plaza indicates Carlson's influence on his beloved city. Honoring Carlson at a dinner in 1928, fellow Jamestowner Justice Robert H. Jackson eloquently stated that Carlson's "leadership writes his name on more pages of our local history than that of any other man. . . . His public life has been good for the soul of the city." In 1943, a *Post-Journal* editorial also honored the former mayor: "At all times [Carlson] sought with intense sincerity and downright honesty of purpose to serve his native town to the utmost of his ability." (Courtesy Jane Currie.)

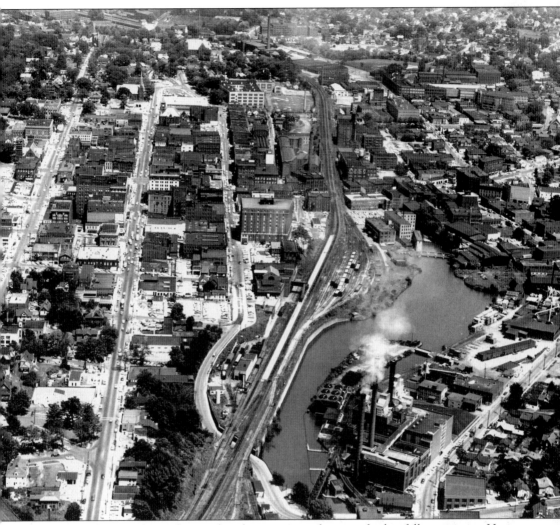

Mayor Samuel A. Carlson advocated a cheap source of energy for his fellow citizens. He is credited with pioneering the establishment of Jamestown's city-owned electric and water plants for residents, local industries, and business concerns. Wisely, the "free-wheeling political maverick" chose knowledgeable businessmen and professionals to develop and manage the Jamestown Board of Public Utilities, whose generating plant (lower right), named for Carlson, is located on the Chadakoin River. The unique public utilities, deemed the largest municipal electric system in New York State, once distributed power to 90 percent of the region and also provided the state's lowest electric rate. (Courtesy Jamestown Manufacturing Association.)

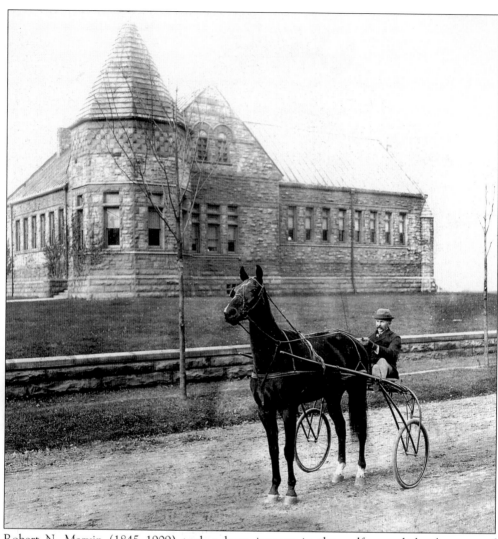

Robert N. Marvin (1845–1909) took a keen interest in the welfare and development of Jamestown and was a guiding spirit in civic affairs. When well-established, Marvin, who began as a bookkeeper, was actively involved with the Chautauqua Lake Railway, Hook and Ladder Company, Gustavus Adolphus Children's Home, National Chautauqua County Bank, telephone company, and James Prendergast Library (background). Marvin also served as town of Ellicott supervisor and was nominated for state senator. A man of culture, his philanthropy extended to the financial and moral support of the Chautauqua Institution. Because of his love of horses and horse racing, Marvin bought property at Fifth and Main Streets. At that time, according to a 2001 article by Florence G. Cass, Fourth and Fifth Streets were "considered parade streets, where those with elegant horses and fine carriages could exhibit their skills in speeding over the only stretch of level ground in the city. . . . Every family of any standing had a carriage and a coachman to take the ladies out for airing and afternoon calling." (Courtesy McCusker family.)

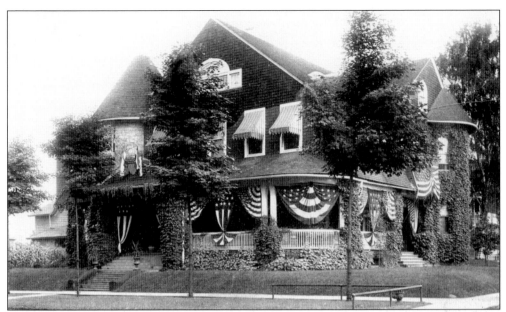

The Marvin Community House, the focus of the 2003 Window on Jamestown Heritage Tour, is a cultural center for women's groups whose purpose "is the moral or mental improvement of women . . . engaged in literary, musical, educational, patriotic, scientific, or historical work." In 1951, some 400 women signed up as charter members of this grand home, whose board members maintain its premises. Shows (art, garden, antiques, and fashion), general programs, and social events are held here. (Courtesy *Post-Journal*, Jamestown.)

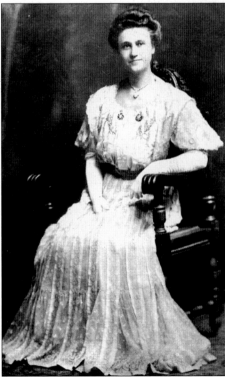

Elizabeth Marvin was educated at Miss Brown's Finishing School in New York City. In 1850, her father moved the family to Jamestown to establish a furniture business. In 1889, Elizabeth, a religious and refined socialite, married the prominent Robert N. Marvin. Horrified at the thought that after her death her home might become a men's social club or be razed to accommodate a gas station, she bequeathed the elegant mansion at 2 West Fifth Street and its furnishings to the women of Jamestown. (Courtesy *Post-Journal*, Jamestown.)

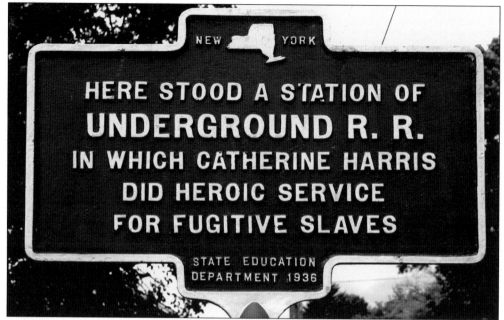

HERE STOOD A STATION OF
UNDERGROUND R. R.
IN WHICH CATHERINE HARRIS
DID HEROIC SERVICE
FOR FUGITIVE SLAVES

STATE EDUCATION
DEPARTMENT 1936

This historic marker site, at 12 West 7th Street near the boat landing, is now the parsonage of the African American Methodist (AME) Zion Church, founded in 1881 by Catherine Dickes Harris (1809–1907). The original home served as a clandestine Underground Railroad station. Despite stiff penalties for aiding runaway slaves, Harris, a free black midwife and nurse, harbored fugitives on the premises. Historian Helen Ebersole believes this home was just "one of a few Negro-operated Underground Railroad stations in America." (Courtesy Jane Currie.)

Like Catherine Harris (left), staunch abolitionist Silas Shearman fed and clothed runaway slaves in his home at Fourth and Pine Streets. As Jamestown's Underground Railroad conductor, he sequestered escapees in his barn and arranged passage to the next station. Escapees en route to Canada fled from station to station along Lake Erie, from Westfield to Buffalo and from Franklin, Pennsylvania, to Buffalo via Jamestown. A fund-raising campaign is seeking to create a tableau of Harris, Shearman, and an anonymous slave to memorialize the city's role in the Underground Railroad movement. (Courtesy Post-Journal, Jamestown.)

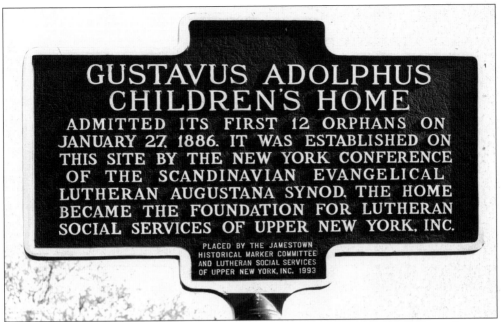

GUSTAVUS ADOLPHUS CHILDREN'S HOME ADMITTED ITS FIRST 12 ORPHANS ON JANUARY 27, 1886. IT WAS ESTABLISHED ON THIS SITE BY THE NEW YORK CONFERENCE OF THE SCANDINAVIAN EVANGELICAL LUTHERAN AUGUSTANA SYNOD. THE HOME BECAME THE FOUNDATION FOR LUTHERAN SOCIAL SERVICES OF UPPER NEW YORK, INC.

PLACED BY THE JAMESTOWN HISTORICAL MARKER COMMITTEE AND LUTHERAN SOCIAL SERVICES OF UPPER NEW YORK, INC. 1993

Another historic marker site, the Gustavus Adolphus Children's Home, on Falconer Street, is one of the most important social service agencies in the area, hailed for serving "orphans, young delinquents, the halt and the weary aged." Its young people have been encouraged to learn, solve problems, and reside with the support of adult role models. Gustavus Adolphus caters to emotionally disturbed youth with care "based on empathy, structure, consistency and a working knowledge of the diverse world in which we live." (Courtesy Jane Currie.)

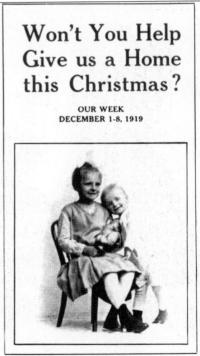

Won't You Help Give us a Home this Christmas?

OUR WEEK
DECEMBER 1-8, 1919

The Gustavus Adolphus orphans' home, established by the Swedish Augustana Lutheran churches, admitted its first 12 orphans in 1886 and, during its first 40 years, nurtured nearly 400 children. One would be hard-pressed to ignore the plea on this 1919 pamphlet's cover, the cherubic children, or this entreaty inside: "You had a home in childhood, help these children who haven't." Although only Swedish orphans were once accepted, children of all social, religious, and ethnic backgrounds have benefited from living at the residence. (Courtesy Gustavus Adolphus Child and Family Services.)

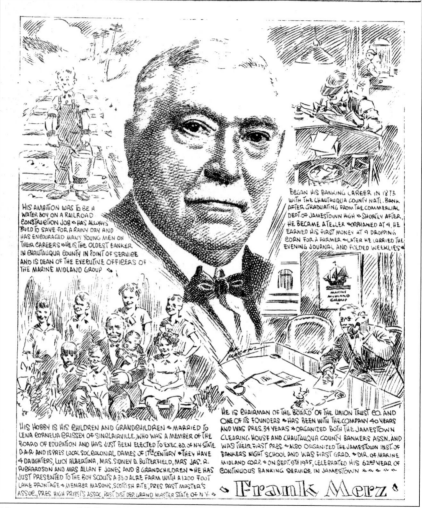

Jamestown's Gallery of Achievement

Series of Pen Portraits by Col. Jack Moranz. Depicting Background and Lives of Prominent Citizens of Jamestown and Vicinity.

HIS AMBITION WAS TO BE A WATER BOY ON A RAILROAD CONSTRUCTION JOB ★ HAS ALWAYS TRIED TO SAVE FOR A RAINY DAY AND HAS ENCOURAGED MANY YOUNG MEN ON THEIR CAREERS ★ HE IS THE OLDEST BANKER IN CHAUTAUQUA COUNTY IN POINT OF SERVICE AND IS DEAN OF THE EXECUTIVE OFFICERS OF THE MARINE MIDLAND GROUP ★

BEGAN HIS BANKING CAREER IN 1873 WITH THE CHAUTAUQUA COUNTY NATL. BANK AFTER GRADUATING FROM THE COMMERCIAL DEPT. OF JAMESTOWN HIGH ★ SHORTLY AFTER, HE BECAME A TELLER ★ ORPHANED AT 4, HE EARNED HIS FIRST MONEY AT 9 DROPPING CORN FOR A FARMER ★ LATER HE CARRIED THE EVENING JOURNAL AND FOLDED WEEKLIES ★

HIS HOBBY IS HIS CHILDREN AND GRANDCHILDREN ★ MARRIED TO LENA CORNELIA CRISSEY OF SINCLAIRVILLE, WHO WAS A MEMBER OF THE BOARD OF EDUCATION AND HAS JUST BEEN ELECTED TO EXEC. BD. OF N.Y. STATE D.A.R. AND IS PRES. LOCAL SOC. COLONIAL DAMES OF 17TH CENTURY ★ THEY HAVE 4 DAUGHTERS, LUCY ALBERTINA, MRS. SIDNEY D. BUTTERFIELD, MRS. JAS. R. RICHARDSON AND MRS. ALLAN F. JONES AND 8 GRANDCHILDREN ★ HE HAS JUST PRESENTED TO THE BOY SCOUTS A 360 ACRE FARM WITH A 1200 FOOT LAKE FRONTAGE ★ MEMBER MASONS, SCOTTISH RITE, PRES. PAST MASTER'S ASSOC., PRES. HIGH PRIEST'S ASSOC, PAST DEP. GRAND MASTER STATE OF N.Y. ★

HE IS CHAIRMAN OF THE BOARD OF THE UNION TRUST CO. AND ONE OF ITS FOUNDERS ★ HAS BEEN WITH THE COMPANY 40 YEARS AND WAS PRES. 34 YEARS ★ ORGANIZED BOTH THE JAMESTOWN CLEARING HOUSE AND CHAUTAUQUA COUNTY BANKERS ASSN. AND WAS THEIR FIRST PRES. ★ ALSO ORGANIZED THE JAMESTOWN INST. OF BANKERS NIGHT SCHOOL AND WAS FIRST GRAD. ★ DIR. OF MARINE MIDLAND CORP. ★ ON SEPT. 9TH 1935, CELEBRATED HIS 62ND YEAR OF CONTINUOUS BANKING SERVICE IN JAMESTOWN ★

★ Frank Merz ★

Frank Merz, a successful financier, was featured in the 1930 "Gallery of Achievement" series published in the *Evening Journal*, highlighting the careers of prominent local citizens. Born in Buffalo and orphaned at an early age, Merz literally worked his way up from a bank messenger to clerk to teller at the National Chautauqua County Bank. He spent 40 years with the Union Trust Company, the first bank affiliated with Marine Midland Corporation of New York, and became the latter's director. Merz organized the Jamestown Institute of Bankers' Night School and became its first graduate in 1927. Eight years later, he celebrated an unprecedented 62nd year of continuous banking service in his adopted city. Many residents recall that Merz generously donated a 360-acre farm with a 1,200-foot frontage on Chautauqua Lake near Mayville to the Boy Scouts. (Courtesy Jim Butterfield.)

As the population increased, businessmen wanted to establish banking in Jamestown rather than deal with institutions in Buffalo. Officials petitioned the state legislature, and in 1831, a charter was granted to the Chautauqua County Bank. The historic marker site for the original bank is at 201 North Main Street. This photograph, however, is of a competitor, the first Bank of Jamestown at 216 Main Street, which opened in 1903 and later relocated to the corner of Second Street. (Courtesy Chautauqua County Historical Society.)

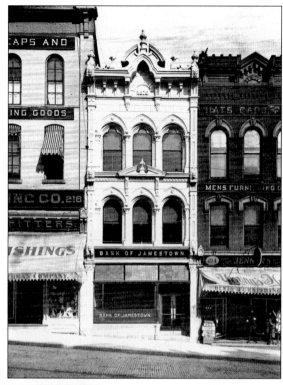

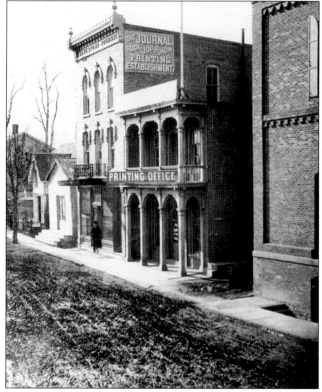

The *Jamestown Journal* was first printed on June 21, 1826, not in this building but in one erected by publisher Adolphus Fletcher at Main and Fourth Streets. Since 1854, the historic marker site has been occupied by St. Luke's Episcopal Church. In 1876, John Adams Hall bought the paper, which was skillfully managed by family members for nearly a century. In 1941, the *Evening Post-Journal* and the *Morning Post* consolidated to become the *Post-Journal,* the only surviving newspaper from the many dailies and weeklies once published in the city. (Courtesy Sydney S. Baker.)

Operating in 1916 in a portion of the Prendergast brothers' store, at First and Main Streets, the post office, like many other entities, has occupied several sites in the city. Judge James Prendergast served as its first postmaster. His successor, Laban Hazeltine, moved the post office into his home. For his personal convenience, Elial Foote, the third postmaster, relocated it into his drugstore. Since 1960, the post office has been housed in the federal building at the corner of East Third Street and Prendergast Avenue. (Courtesy Edward Schaefer.)

The Jamestown Fire Department, shown c. 1915, was located adjacent to city hall. By 1886, the department consisted of some 200 volunteers in six fire stations. Just as the horse-drawn hose wagons and steam pumpers were replaced by fire trucks and fire engines, the volunteer forces were replaced by paid professional firefighters. (Courtesy Edward Schaefer.)

Six

THE HEART OF THE CITY

To learn a bit about the Jamestown of earlier years, the authors interviewed two lifelong city residents, both active community members who have maintained close ties to their family, church, and neighborhood. Through their eyes, the reader is given a flavor of two distinct commercial districts of the city: downtown and Brooklyn Square.

First, Bob Bargar kindly took time to walk the authors through downtown in the late 1920s, remembering it as a young man. Bargar defined downtown's parameters as the area bounded on the west by what is now the Third Street Bridge to Foote Avenue on the east and from Fourth Street on the north south through and including Brooklyn Square.

In those days people literally walked everywhere along Jamestown's red brick–paved streets— even through the rough western New York winters. Only on special occasions did they ride in horse-drawn sleighs or trolleys. When he worked for his father, Crawford Bargar, the vice-president and division manager of the S. M. Flickinger Company, Bob Bargar walked from his home at 406 West Sixth Street down to the business on Taylor Street in Brooklyn Square, went home for lunch, and then retraced his steps in the afternoon—as did most businessmen, factory workers, and schoolchildren.

En route to work, Bargar passed many large office buildings, banks, hotels, and retail stores in the vicinity of Third Street and Main. Upon entering the Brooklyn Square district across the river at the bottom of the hill, he would encounter a similarly animated scene: activity at the public market, theater, hotel, restaurants, and shops, which also attracted passengers from Pennsylvania who arrived on the Warren-Jamestown trolley line. Bargar still recalls the "clanging of bells" and remembers the excitement caused by the pair of galloping horses that would "snort and bellow" as they pulled the district fire station's pumper to the hydrant to quell local fires.

In a similar fashion, Fran Galbato, a former PTA Council president and current president of Brigiotta's Farmland Produce and Garden Center, shared memories of her roots in Brooklyn Square. It was primarily an Italian community begun after 1900, and most residents hailed from the small village of Tortorici in Sicily. The Derby Street environs became a close-knit, heavily populated community.

Galbato emphasized the neighborhood's camaraderie rather than its trade and business dealings. Houses close together invited intimate relationships. Lifelong friends and family gathered on front porches to socialize. Others would sing, dance, and play guitars and accordions in front of homes and neighborhood stores. Galbato emphasized that these families laughed and cried and played together, watched out for each other's children, never turned their backs on each other and, most importantly, stayed in close contact.

As in the downtown district, shoppers in Brooklyn Square walked to their corner grocer, tailor, creamery, or bakery, patronizing only nearby stores. Students and churchgoers also attended neighborhood facilities.

Automobiles, however, forever altered the daily life of all city residents. According to Bargar, Jamestown, like most other urban areas, experienced a metamorphosis. Driving provided a new freedom; personal vehicles enabled families to venture farther and farther from their homes and neighborhoods. Because of high-volume trade and spacious parking lots, family-owned groceries, for example, were unable to compete with the large supermarket chains that cropped up on the city's outskirts. Many retailers felt compelled to relocate to the suburban shopping centers and, in 1970, to the Chautauqua Mall and adjacent strip malls.

In essence, both commercial districts, downtown and Brooklyn Square, within walking distance of their clientele, became anachronistic. Out of business, the once familiar buildings sat vacant or were razed in the name of progress.

Although Bob Bargar had retired as president of the Jamestown division of the thriving Flickinger Company—the wholesale food distributorship that had grown to a total of 220 employees—he remained attuned to and concerned for Jamestown's needs. It was obvious to Bargar that the key to downtown's future depended upon the availability of parking. As a result, he devoted his efforts to raising seed money from local merchants and banks to help fund the Jamestown Civic Auto Ramp project, a successful undertaking.

With the demise of Brooklyn Square and the Lost Neighborhood, in particular, the Galbato family had no choice but to leave and start anew. Fran Galbato's transplanted family and friends now gather at Brigiotta's, on Fairmount Avenue, to reminisce about their former home and store.

Symbolic of the best of Jamestown citizenry, both Bob Bargar and Fran Galbato have made significant contributions to the heart of their city.

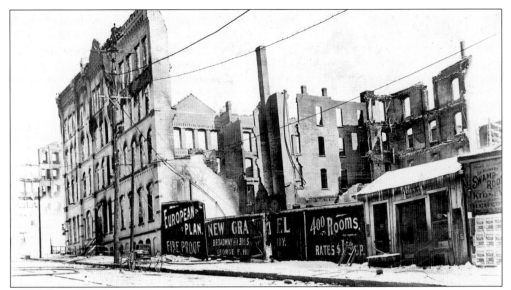

Following 19th century fires, a newspaper reporter prophesied in 1861 that "like the Phoenix, our village will . . . arise from its ashes. Main Street will likely be widened, and within a year or two, present a more imposing appearance that ever." However, another fire's fury wreaked havoc in March 1910. The Gokey fire began in the Gokey Shoe Company, on Cherry Street. It spread rapidly to offices and stores located on Third Street and across the street to the Sherman House, whose rear view illustrates the fire's vengeance. Ironically, the sign farthest to the rear advertised the hotel to be "Fireproof." This historic marker site is at 20 West Third Street. (Courtesy Sydney S. Baker.)

Despite the valiant efforts of Jamestown's volunteer firemen, by the end of the third day, the ravaging Gokey fire had destroyed a huge number of the city's central district's businesses, offices, and dwellings. The creation of the professional Jamestown Fire Department was a direct result of this catastrophe. The era of the horse-drawn fire department conveyances, recalled by Bob Bargar, became a mere memory. (Courtesy Edward Schaefer.)

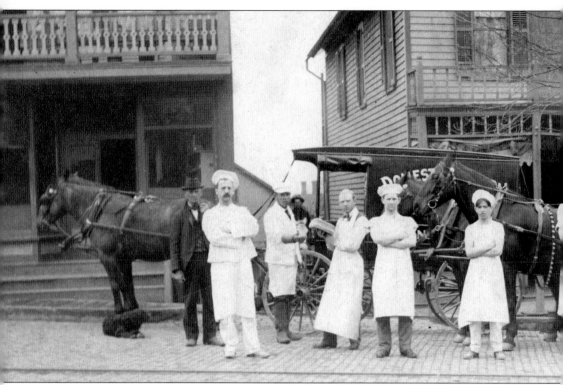

Families once depended upon home delivery service for their staples. The Domestic Bakery Company employed horse-drawn wagons and many employees, as seen posing in front of the 707 North Main Street establishment. Like the driver of the Jones & Ahlquist wagon (below), some

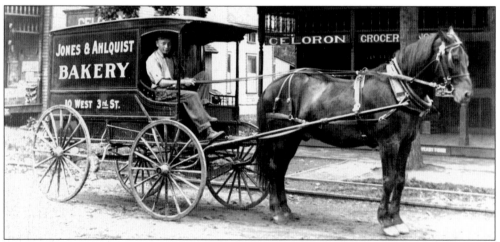

Beginning in 1908, the Jones & Ahlquist delivery wagon was a familiar sight. Today, this photograph hangs in the Jones Tasty Baking Company, on Pine Street. The renowned Swedish bakery, founded by Frank T. Jones and continuously managed by family members, is currently run by the founder's grandchildren. Despite its location and name changes, Jones's bakery has been one of Jamestown's prides and traditions. Deliveries to out-of-town residents who crave hometown *limpa* rye bread and other Swedish specialties are commonplace for former residents, including comedienne Lucille Ball. (Courtesy Richard M. Jones family.)

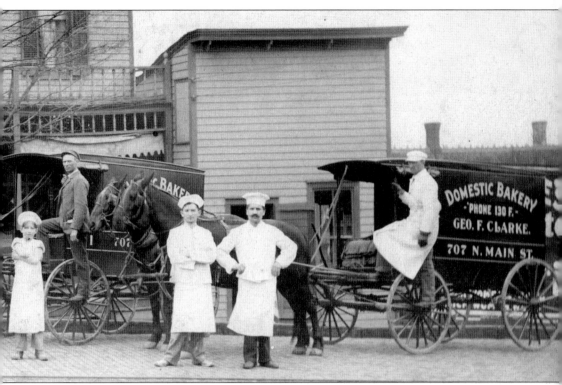

companies made deliveries not only from their shops to private residences but also to hundreds of grocery outlets in Jamestown and the surrounding vicinity and to the boat landing for steamers en route to various locations around Chautauqua Lake. (Courtesy Marilyn Johnson.)

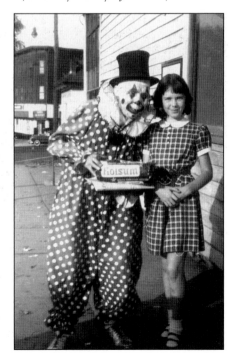

There were many bakeries in Jamestown and, as a result, competition was fierce. Holsum bread was sold by Jamestown Baking Company, on North Main Street. The hired clown, a clever promotional idea, was irresistible to many children including this girl. (Courtesy Roy Swanson.)

Soon after Swedish natives John and Fred Swanson arrived in Jamestown in 1892 from Kane, Pennsylvania, they opened a blacksmith shop that expanded into this three-story livery stable. Their successful business, one of 13 area livery stables, grew to a total of 42 horses and 60 rigs; the latter were used for funerals, weddings, and other special occasions. The brothers also specialized in carriage manufacturing, repairing, and painting. The Holiday Inn now occupies this site, at the corner of West Fourth and Cherry Streets. (Courtesy *Post-Journal*, Jamestown.)

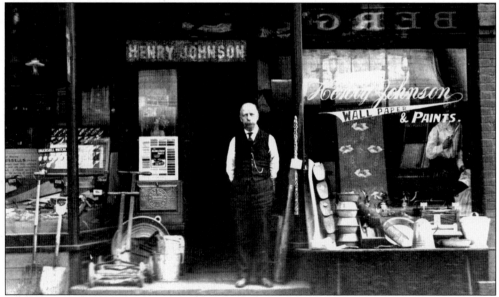

Henry Johnson, standing in the doorway of his store at 12 East Second Street in 1910, considered himself "the low price seller of hardware, wallpaper and paints." Martin Henry Johnson remembers his grandfather Henry Johnson as a parsimonious Swede and a pack rat who saved virtually everything. Henry Johnson's basket of hickory nutshells burnished tools forged at the Crescent Tool Company, which he and fellow Swedes, knowledgeable about iron from their native country, supposedly founded. (Courtesy Sheridan R. Johnson family.)

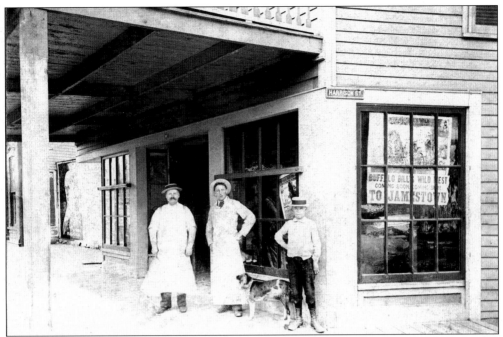

Ebba and Wilbur Ekback's meat market-butcher shop, at the corner of Thayer and Newton Streets in the northern part of the city, was typical of the once busy neighborhood stores that have vanished. The couple carried on the family tradition of Wilbur's grandfather who had owned Ekback Meat Market in Brooklyn Square near the Humphrey House. Note the poster in the window advertising the visit of Buffalo Bill to the area. (Courtesy Wilbur A. Ekback Jr.)

In 1910, the Buffalo Bill Wild West show was held in nearby Falconer at the eastern edge of Jamestown. (Courtesy Jane Currie.)

65

Hatting, one of Jamestown's first industries, appealed mostly to women; yet, custom-made fur and wool hats were extremely popular with men. By 1873, the village business directory listed nine millinery shops. Like the ladies in this vintage photograph, proprietors Louisa Defendorf and Mary Parsons operated a shop that stocked decorative adornments, bins filled with spools of ribbon, and individual hatboxes for their discriminating clients. In addition, they often sold hair switches, ladies furnishings, and other fancy goods. (Courtesy *Post-Journal*, Jamestown.)

Ethel Louise Carlson Peterson's elegantly formal dress, gloves, and chapeau, seen in this portrait *c.* 1910, could have been fabricated in Jamestown. The C. L. Thom millinery shop, on West Third Street, for example, offered nearly 400 trimmed hats, many created from sophisticated Parisienne patterns. Presumably, many readers, in addition to Peterson's daughter, have such heirloom portraits tucked away in their own family scrapbooks. (Courtesy Shirley Raymond.)

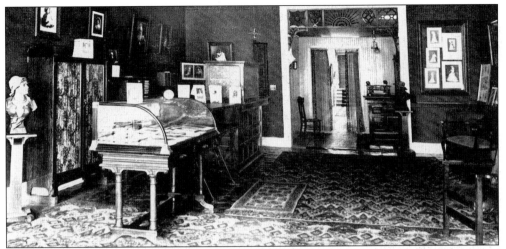

The A. N. Camp Company was one of the area's most successful photography studios. When A. N. Camp retired in 1919, J. Stuart Husband assumed ownership, specializing in portrait, field, and commercial photography, incorporating the latest techniques and equipment. Many Camp studio images can be found in local historical archives and provide insight into Jamestown's past. (Courtesy Edward Schaefer.)

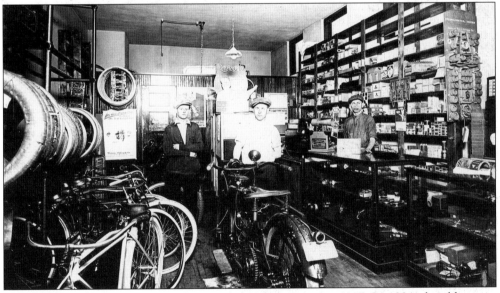

The Lundberg family emigrated from Sweden to Jamestown in 1917. In 1924, the eldest son, Rudolph, a cabinetmaker, partnered with Ludwig Anderson and Axel Pearson to form the original Jamestown Cycle Shop, on Prendergast Avenue near Third Street. The shop sold bicycles, Harley-Davidson motorcycles, fishing tackle, boats and outboard motors, hunting supplies, and sporting goods, as well as provided a service department. Rudolph Lundberg continued its management alone from 1925 until 1949, when it was acquired by his siblings Harry and Harriet Lundberg Jones. In 1953, Harry's son Dennis became his father's partner, and after 50 years in the business, he, too, retired. Located at 10 Harrison Street, the 79-year-old operation has sold more than 65,000 bicycles, primarily Schwinns. The popular adjunct Jock Shop, which specializes in athletic clothing and equipment, was not added until 1974. (Courtesy Dennis H. Lundberg.)

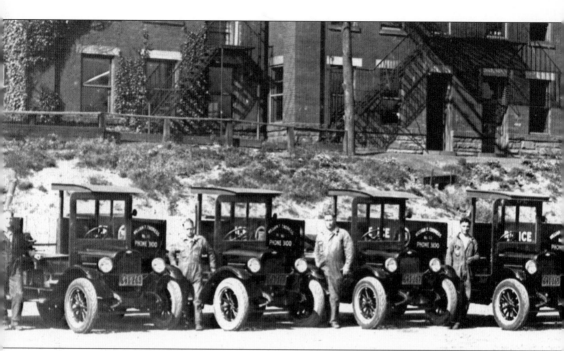

The William F. Endress Company was established in 1897 and continues to operate today as the Jamestown Ice and Storage Company, at 66 Foote Avenue. The company's fleet of ice trucks and deliverymen are lined up, with Jamestown High School in the background. Before returning home to his family's business, Col. William F. Endress, a graduate of the U.S. Military

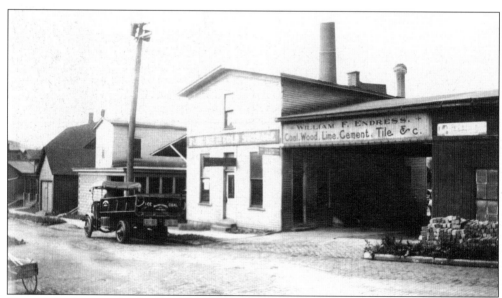

This 1920 photograph clearly shows that the Endress wholesale and retail business, once located adjacent to the Maddox Table Company, specialized in the sale of coal—anthracite, bituminous and blacksmith—wood, lime, cement, and tile. Rather than rely on the icehouses around Chautauqua Lake, Endress produced the area's first artificial ice and was the first freezer storage company in the city. (Courtesy Orrie Hoover.)

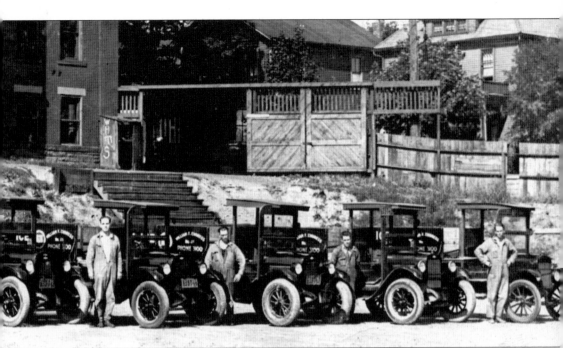

Academy, spent several years in Cuba. He was not only the president of the Spanish Electric Company but also one of the first to navigate a ship through the Panama Canal while in the Army Corps of Engineers. (Courtesy Orrie Hoover.)

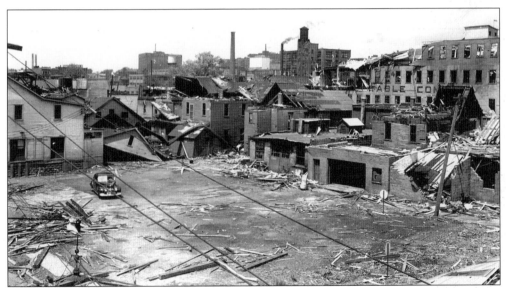

Longtime residents may recall the devastating winds of June 10, 1945, that decimated much of Jamestown's industrial section and caused millions of dollars worth of damage. In this frequently seen image of the tornado's wrath, with the fallen trees and debris is the Maddox Table Company (far right), established by the Shearman family in 1898; the top floors of the huge wooden structure on Harrison Street were totally destroyed. Previously, the Maddox business produced fine oak, maple, and mahogany furniture, which was shipped throughout the United States, as well as to England, Australia, Japan, and China. (Courtesy Orrie Hoover.)

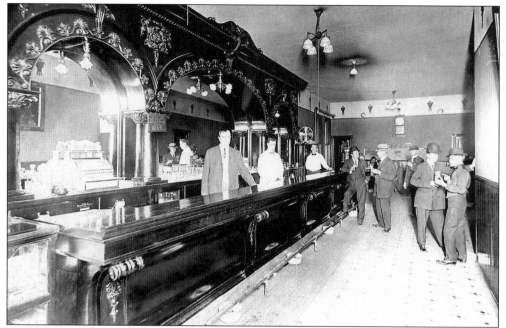

Located at 217 Washington Street, the Pullman Café was owned by stepbrothers James Mecusker (in the dark coat behind the bar) and Horace R. Mecusker, who was also a livery stable owner. When Prohibition caused the café to close, James, the grandfather of Jim McCusker, the longtime proprietor of the Pub on North Main Street, joined the city's police force and later worked on the J. W. and N. W. trolley line. (Courtesy McCusker family.)

The Pullman restaurant and tavern had two entrances, one for the upstairs dining room and one for the parlors. Its advertisement read, "a place where Ladies can enjoy a refreshing glass of beer and a quiet chat without being molested in any way. No rowdyism, nor vulgar or profane language; no intoxicated people. We guarantee ladies visiting these parlors the same protection that would be given them by father, brother or husband." (Courtesy McCusker family.)

The Hawkins Restaurant was located at 14 East Third Street for five decades. Its counter was always busy serving meals "just like home." Chief cook, bottle-washer, and waiter Lawrence E. Lamb owned the establishment from 1929 until 1939, after which he ran the Tap Room on Route 20 in Westfield until his retirement in 1981. In this photograph, Lamb appears to be tenderizing his entrée. (Courtesy Lawrence E. Lamb family.)

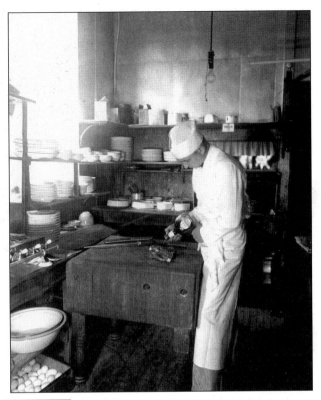

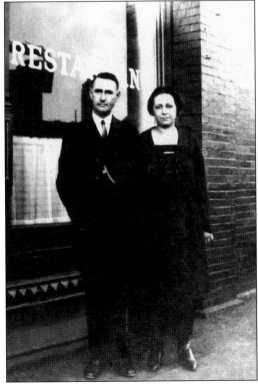

Pictured in 1921, this First Street restaurant near today's Union Gospel Mission was owned by Earle H. Lamb and his wife, Hilda Sophia Peterson Lamb, who often hosted immigrants arriving at the nearby railroad depot. Like many Swedish-speaking people, Hilda Lamb was aware of the necessity of greeting newcomers in their native language. Earle Lamb's granddaughter also recalls that he would hitch Kit to the buckboard to deliver fresh produce and eggs from his Orr Street Extension farm to sell at the public market in Brooklyn Square. (Courtesy Lawrence E. Lamb family.)

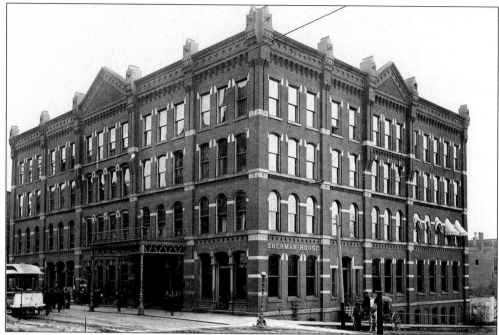

The four-story Sherman House, which burned in the Gokey fire of 1910, was the predecessor of the Hotel Samuels. Built in 1881 to accommodate railroad and steamboat passengers, its central location in the downtown district made it the ideal waiting room for the Jamestown Street Railway Company's electric trolleys. (Courtesy Edward Schaefer.)

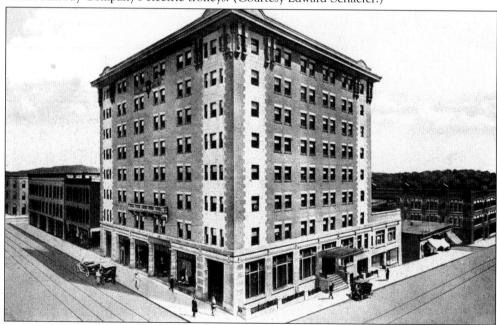

The eight-story Hotel Samuels, at the corner of Cherry and West Third Streets, boasted 250 fireproof rooms, elegant cuisine, long-distance telephone service, a smoker's emporium, a grillroom, convention rooms, and manicure and billiard parlors. In addition, both the Rotary and Kiwanis Clubs held weekly luncheons here. (Courtesy Edward Schaefer.)

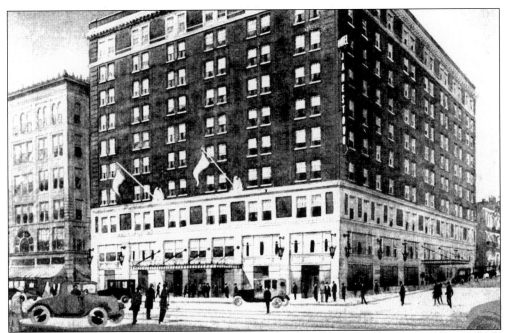

Like other hostelries including the Humphrey House, the Hotel Jamestown on Third Street in the heart of the business district was built to provide adequate facilities for visiting furniture buyers. Locally owned and operated, the hotel welcomed not only commercial travelers but also vacationers, as it was the "ideal resting place from which to journey forth on broad paved highways to view the beauteous countryside or revel in the glories of Lake Chautauqua." Its Crystal Ballroom is well remembered as the site of special dances, banquets, conventions, and high-school reunions. (Courtesy Edward Schaefer.)

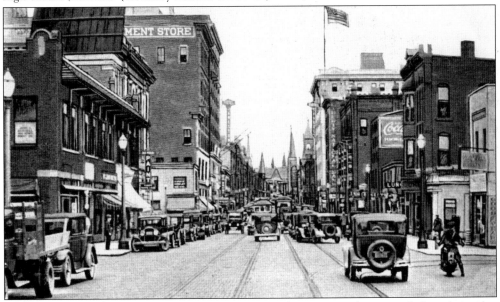

Replacing the electric trolleys, automobiles are seen driving over the outmoded tracks in this view of Third Street, looking eastward toward the conspicuous Methodist Episcopal church's steeple. (Courtesy Edward Schaefer.)

Frank Donato operated his Budweiser beer distributorship on East Second Street during the early 1930s. While delivering, he stopped his horses in front of Brigiotta's grocery store, at 25 South Main Street. Teenager Franny Brigiotta remembers that Donato, their family friend, came inside to get her for this pose. Before selling his Budweiser franchise to Arthur R. Gren, Donato moved this business and his wholesale produce operation to Eighth Street. (Courtesy Mary Jean Donato.)

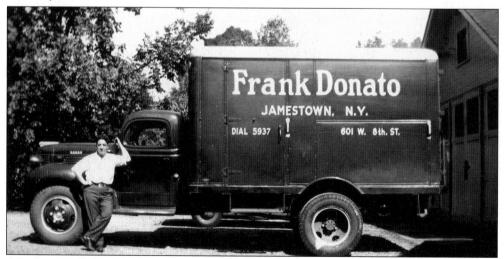

After his grandfather's death in 1956, Frank A. Donato carried on the wholesale produce company. He is seen here leaning on his grandfather's delivery truck. (Courtesy Mary Jean Donato.)

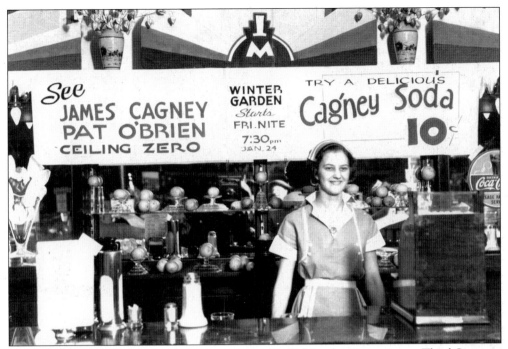

Marian Ahlgren Halvarson was a waitress at the G. C. Murphy Company on Third Street in 1935. A popular section of the five-and-dime store was the lunch counter and soda fountain, where friends would rendezvous. Today, the site is occupied by Kwik Kopy Printing and the Golden Gate Deli. (Courtesy Marian E. Halvarson.)

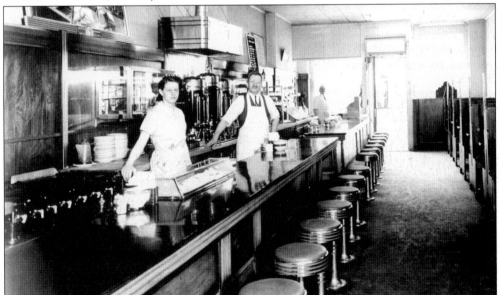

Another popular lunch counter was the Waffle and Sandwich Shoppe (formerly Mattia's), at 219 West Third Street near the Jamestown Savings Bank Ice Skating Arena. This early-1940s photograph shows owner Angelo Michos (center) and Costa Tangelos (near the window). Today, Michos's granddaughter Tina and her husband, Chris Merchant, carry on the family's tradition as owners of Mariner's Pier Restaurant in Celoron. (Courtesy Michos family.)

Circa 1941

LIND FUNERAL HOME
254 South Main Street
Jamestown, New York

The Lind Funeral Home, a well-respected family business, was founded by Bernhard F. and Dorothy E. Lind in 1935 in this house, which still stands at 254 South Main Street. The roomy Packard automobile, parked in front, was needed to accommodate the couple's six children: sons B. Rodney, Robert C., and Herbert W., and daughters Andrea M. Hyde, Ruth E. Donelson, and Carol A. Kindberg. Third-generation family members now operate the West Third Street mortuary business with exemplary dignity and efficiency and with sincere concern for families' well being. (Courtesy Lind Funeral Home Inc.)

In business just shy of 100 years, Reuben W. Bigelow, with his partner Charles F. Abrahamson, opened the C. F. Abrahamson Company in 1888, specializing in dry goods. At 207 North Main Street, the six-story operation grew from a staff of 15 to become the several-storied Bigelow's Department Store. Despite the accessibility of the Chautauqua Mall, with its numerous retail stores, Bigelow's, at the corner of Third and Washington Streets, along with Nelson's Department Store on Second Street, Nord's, the Three Carlson Sisters Dress Shop, and many others in the downtown district, are sorely missed. (Courtesy *Post-Journal*, Jamestown.)

The Breakfast Party, sponsored by WJTN radio, which first aired in 1946, is considered to be one of the longest running family radio shows in the United States. Throughout the years, it has been a Saturday morning feature, broadcast on location from various venues. This particular image captures "the oldest lady guest" with announcer J. Ralph Carlson during a Breakfast with Bigelow's presentation. (Courtesy Kathleen Crocker.)

Taken on June 24, 1938, the last day of school, this photograph shows Nancy Lamb (left) and her sister Mable sitting on the steps of Hawkins Restaurant, owned by their father Lawrence Lamb, seated between them. Roselle's Barber Shop (next door) was owned by Philip Roselle, brother of WJTN announcer Jim Roselle. (Courtesy Lawrence E. Lamb family.)

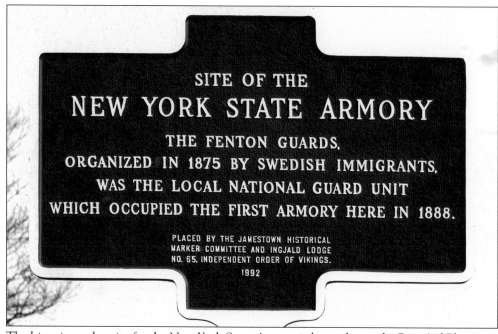

The historic marker site for the New York State Armory is located near the Rite Aid Pharmacy on South Main Street. The facility was relocated here to Brooklyn Square in 1892, after the original armory, located in the Congregational church, burned. (Courtesy Jane Currie.)

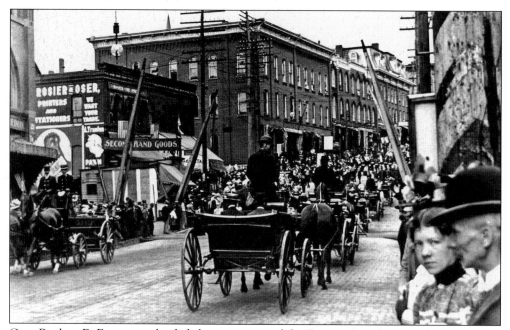

Gov. Reuben E. Fenton applauded the patriotism of the Fenton Guards, named in his honor. In August 1885, the Fenton Guards served as an escort in the governor's funeral procession. The unit was also invited to participate in the 1901 Pan-American Exposition in Buffalo and the St. Louis World's Fair three years later. Fenton's own son served as a guard in the late 1800s. (Courtesy Winton "Ed" Edwards.)

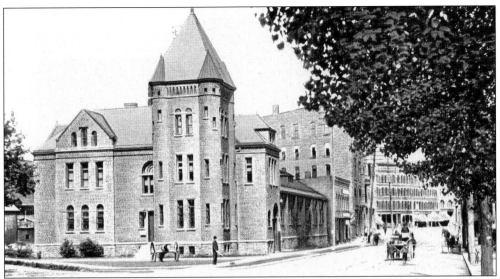

The Fenton Guards, the first separate military company organized in New York State, was composed primarily of Swedish Americans. The group adopted the yellow-trimmed blue uniform worn by the bodyguards of Sweden's King Charles II. Members' attire changed after 1887, when men of other nationalities joined their ranks. The city's welfare department, located in the armory, lost valuable records when that building burned. The regiment moved into its current home, in the Porter Avenue Armory, in 1932. After the terrorist attack of September 11, 2001, the facility was secured and closed to the public. (Courtesy Kathleen Crocker.)

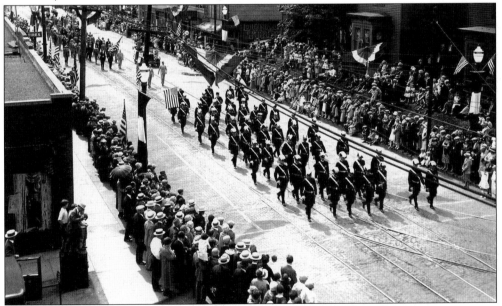

The Fenton Guards are seen here on parade in 1898, preceding their call to duty as volunteers in the Spanish-American War. The unit was activated several times: during Buffalo's 1892 railroad strike, to act as an escort to Pres. Theodore Roosevelt during his visit to the Chautauqua Institution in 1905, during the Mexican border dispute in 1916, and for a later altercation at the downstate Auburn State Correctional Facility. (Courtesy Chautauqua County Historical Society.)

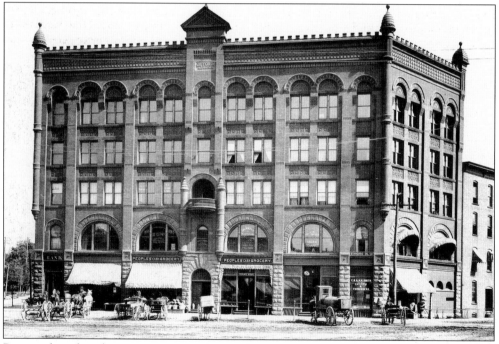

BROOKLYN SQUARE

CALLED BROOKLYN SQUARE SINCE THE 1860's, THIS AREA HAS BEEN AN INDUSTRIAL AND COMMERCIAL CENTER SINCE 1848.

JAMESTOWN CENTENNIAL COMMITTEE
STATE OF NEW YORK 1966

An historic marker site at the foot of Main Street south of the railroad viaduct, Brooklyn Square, along with the Third Street commercial district, was once considered the heart of the city. A bustling area since the 1860s, it was drastically reconfigured during the 1970s urban renewal project, ostensibly to create a more vibrant business community. (Courtesy Jane Currie.)

Prior to their demolition in 1969, two thriving businesses in Brooklyn Square were in this five-story Gifford Building, whose lower level housed a variety of retail stores, and the centrally located Humphrey House, the terminal for the Warren-Jamestown trolley. The trolley provided patrons from outlying districts easy access to the square. Note the hitching posts to accommodate visitors arriving in horse-drawn carts, wagons, and carriages. (Courtesy Sydney S. Baker.)

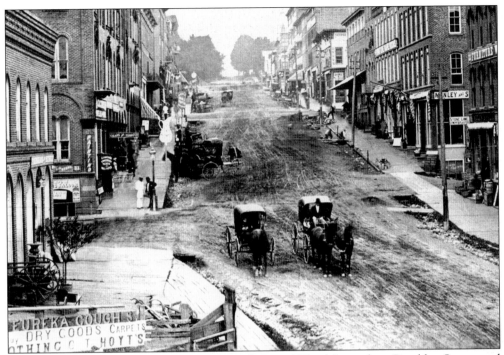

This familiar view of Main Street, looking north toward Third Street from Brooklyn Square and the Chadakoin River, clearly depicts a populated district of the city in 1875. Nine years later, the Jamestown Street Railway Company would lay tracks on this hill, convey more people to the area, and effect minor traffic congestion. (Courtesy Chautauqua County Historical Society.)

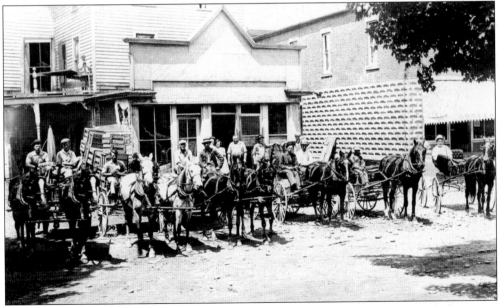

The Kent Dairy, located in the Brooklyn Square district, was another of the many independently owned family businesses scattered throughout the heart of the city. Facing the street, several horse-drawn delivery wagons and drivers appear to be ready to accommodate their customers as soon as beckoned. (Courtesy Kent family.)

Before the railroad viaduct crossed over Main Street in the mid-1920s, many small businesses were located in the Warner Block. This Depression-era photograph, looking south, reflects the times. Note the American Pawn Broker shop near the Texas Hot, the drugstore, and shoeshine parlor. In the middle of the steps leading up to the present-day Jochum Business Systems store, advertisements offer "bargains in Victrolas" and "20% off new rugs." (Courtesy Tom and Frank Buttafarro.)

Horse-drawn plows were used to clear city sidewalks from the 1940s until the late 1960s. Everett "Swede" Nelson (identified here), Earl Hall, and Milo Mansfield all contracted with the city of Jamestown and were responsible for snow removal in three different areas. Between midnight and 6:00 a.m., for example, both sides of Willard Street from Allen to the city line would be cleared by the horse-pulled V-plow led by its exhausted human partner, who would then report to his daytime job. Remember, also, that Jamestown is a city of hills, making the task often difficult and sometimes treacherous. (Courtesy *Post-Journal*, Jamestown.)

The Lost Neighborhood was considered by many to be the area in Brooklyn Square once bordered by Harrison, Main, Allen, and Institute Streets. Most of its predominantly Italian residents fondly remember Albanos's Grocery, the Derby Street cheese factory and, especially, Brigiotta's Grocery and adjacent Johnny's Lunch. Only the latter two businesses survived and still flourish at their Fairmount Avenue locations. (Courtesy Galbato and Calamunci families.)

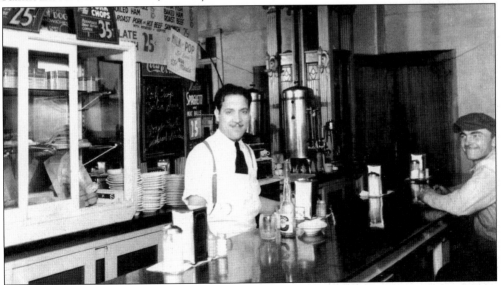

Johnny's Lunch, an integral part of Brooklyn Square for years, was located in a portion of the Humphrey Hotel. This photograph of owner Johnny Colera (behind the counter) and customer Orville Luce hangs in the contemporary Johnny's Lunch, on Fairmount Avenue. With great pride, Colera's daughter, Dianne Calamunci, and her children carry on the family tradition by maintaining an active role in the ever popular restaurant. (Courtesy Calamunci family.)

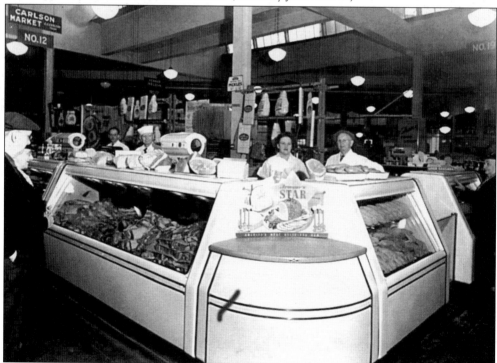

PUBLIC MARKET
FORESHADOWING SUPERMARKETS
AND MALLS, NUMEROUS VENDORS,
OFTEN RECENT IMMIGRANTS, SOLD
PRODUCE, MEATS, AND OTHER FOODS
INCLUDING ETHNIC SPECIALTIES
FROM 1913 TO 1965.
PLACED BY JAMESTOWN HISTORICAL MARKER COMMITTEE 2000

The public market was razed in 1966, one year after it was permanently closed. Its historic marker site is located at the foot of Forest Avenue and Harrison Street. Because of the diverse ethnicity of the individual stall owners, the market was aptly termed "the melting pot of Jamestown" and "a mecca for Jamestown housewives," although many late-shift factory workers also stopped by the market en route home. (Courtesy Jane Currie.)

The Swedish butcher-meat market, stalls No. 11 and 12 at the city public market, were managed by the Carlson family. The men behind the counter are, from left to right, J. Henry Carlson, Oscar Carlson, and their father, Carl S. Carlson (to the right of the young woman). The customers are identified as Mr. and Mrs. John Soderquist. (Courtesy *Post-Journal*, Jamestown.)

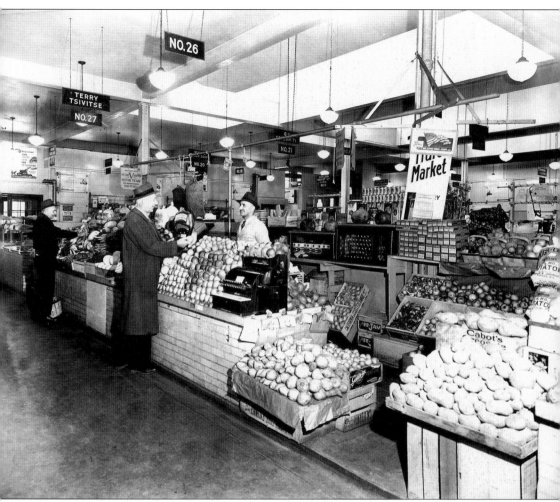

Advertised specials on the finest of ethnic foods at the lowest possible prices enticed more than 10,000 customers to attend the reopening of the public market in 1934. Italian stall owners generally sold fruits and vegetables grown on their farms, while Albanians featured exotic fruits and sweets. Market stalls No. 26 and 27 appear to be owned by Terry Tsivitse. The bags of potatoes and onions are neatly displayed for the well-dressed customers. Some stalls sold a variety of produce, including sweet peas, bananas, cucumbers, grapes, and seedless California and Florida oranges, while others specialized in butter, eggs, coffee, lard, and home baked goods. Signs hanging throughout the market relate to the war years, when money was very scarce. To the far left, a poster reads, "V for Victory; Help win the war." To this day, residents dearly miss the exceptional market. (Courtesy Marilyn Johnson.)

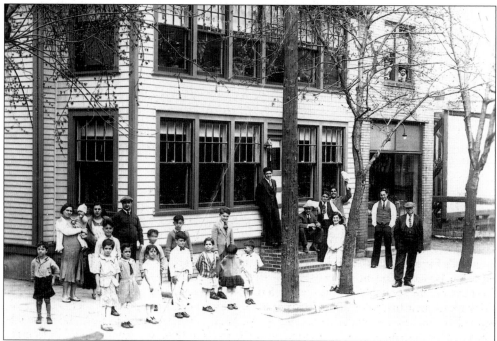

THE LOST NEIGHBORHOOD

THE HARRISON-DERBY-VICTORIA NEIGHBORHOOD WAS HOME TO NEARLY 100 PREDOMINANTLY ITALIAN-AMERICAN FAMILIES. THEY WERE DISPLACED BY THE URBAN RENEWAL PROJECT OF THE 1970's. THIS AREA EAST OF MAIN STREET TO THE CHADAKOIN RIVER WAS THE ONLY RESIDENTIAL NEIGHBORHOOD AFFECTED BY THE PROJECT.

PLACED BY THE LOST NEIGHBORHOOD COMMITTEE AND THE JAMESTOWN HISTORICAL MARKER COMMITTEE
2003

The Lost Neighborhood historic marker site, the 50th of its kind, was placed on South Main Street across from the Rite Aid Pharmacy in October 2003. It commemorates the more than 100 businesses and families that, during the 1970s urban renewal project, were forced to relocate in the name of progress. A surprisingly large number of former residents attended the Lost Neighborhood's first annual reunion at St. James Hall in 2003 to share stories, memories, and photographs of a bygone era. (Courtesy Jane Currie.)

Because of the popularity of Brigiotta's Grocery, at 41 Derby Street, neighborhood gatherings such as the c. 1930 one shown here were typical. The long, narrow store, an addition to the far right of the original house, sold imported Italian food, beans, rice, pasta, and flour in bulk. Perhaps the photographer who rented upstairs rooms took this photograph, capturing even the young Brigiotta children leaning out the windows (right). (Courtesy Galbato family.)

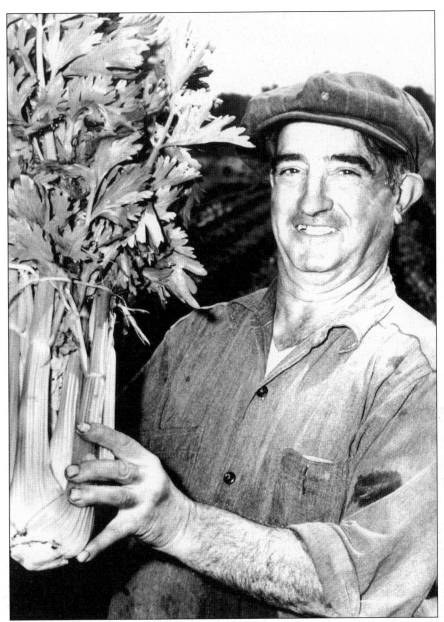

Brigiotta's Farmland Produce and Garden Center had its origins in 1924 on Derby Street in Brooklyn Square. The Brigiotta family then bought a 70-acre farm on Jones and Gifford Avenues, where vegetables thrived in the fertile swampy soil. Many Italian-American citizens today recall their first job working on that farm, raising and picking cabbage, lettuce, onions, and celery. The farm's produce was sold in the family's nearby open-air fruit and vegetable market to local businesses and trucked to nearby markets in Buffalo, Cleveland, and Pittsburgh. In 1944, owners Anthony and Josephine Brigiotta sold their interest to their children, who have continued to maintain a high-quality and high-volume trade. The business has grown to a staff of 80 employees and is currently headquartered in front of the original Broadhead carriage house on Fairmount Avenue. Grandfather Toni Brigiotta, the family patriarch, proudly displays his prizewinning 11-pound celery. (Courtesy Galbato family.)

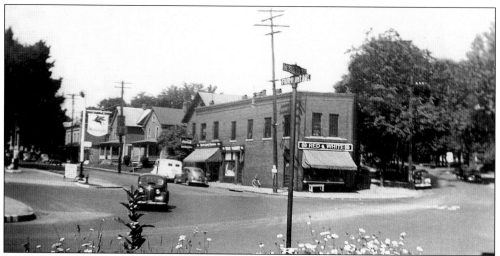

According to *Saga from the Hills*, "the [public] market was a hapless casualty of impatient traffic and supermarkets." The mom-and-pop stores that existed in every neighborhood and the emerging self-service *groceterias* met the same fate. Small franchises like Wilt's Red and White store, located near the intersection of Hall, Livingston, Fairmount, and Sixth Streets, along with 24 other Red and Whites in the greater Jamestown area were forced out of business due to competition. (Courtesy Roy Swanson.)

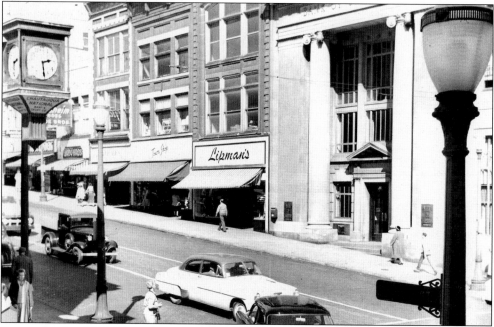

Except for the 1954 Chevrolet and other vintage automobiles and clothing, this corner at North Main and Second Streets seems, at first glance, to have remained mostly unchanged. Until the completion of the Chautauqua Mall in Lakewood, banks, restaurants, and these individually owned stores attracted many customers. A priority of Jamestown's current administration is to revitalize the city's downtown sector, which has already witnessed a renaissance during the past couple of years with the construction of the west end's Jamestown Savings Bank Ice Arena and the nearby Best Western Hotel. (Courtesy Roy Swanson.)

Seven

RELIGION AND
EDUCATION

According to historians, it was James Prendergast, "through the trying times of [Jamestown's] infancy . . . who furnished the people with employment; extended an open hand to the needy; and, furnished the means of education."

Both religion and education have been an integral part of Jamestown since the early settlement. Before formal public schools were introduced, churches assumed the responsibility for educating the children of parishioners, generally in their native language. Regardless of the denomination, "the family Bible was the most precious of the few valuable possessions which the pioneers were able to bring with them into the Holland Purchase [territory]," according to the late county historian Elizabeth L. Crocker.

Missionary John Spencer initiated small prayer meetings in cabins as he traveled throughout the Chautauqua region as a circuit rider preacher. These small gatherings bonded neighbors and families together in worship and, in the 19th century, the first organized churches in the city were established by the English, Swedish, and Italians.

Jamestown's diverse ethnic population was evident in a locally produced 2003 video entitled *Our Town*, which portrayed many facets of the city. The religious segment of the program noted that upon entering the Jamestown city limits from the north, a row of houses of worship, all less than a mile from each other, represents numerous faiths: Latin American, Roman Catholic, Methodist, Greek Orthodox, Jewish, and Islamic.

In order to build the physical, mental, and moral life of the pioneer community, Prendergast advocated schooling for all the children of the settlement and, for many years, bore the entire cost of that education, providing the facilities, teachers, and supplies. The first school was held in the Blower's cabin and, when the Prendergast Academy was established, James Prendergast permitted the First Congregational Church to conduct its meetings and services there as well.

Numerous individuals impacted the growth of the Jamestown public school system throughout the years. Prof. Samuel Gurley Love (1821–1893), a graduate of Hamilton College, came west from Orleans County. After his involvement with schools in Buffalo, he served as principal of the Randolph Academy before his assignment as Jamestown's first superintendent of schools. Associated with the school system from 1865 to 1890, Love has been credited with laying the strong foundation for Jamestown's public education.

Because of the preponderance of local industries in the 1870s, Love advocated classroom instruction of practical subjects and, thus, introduced innovative programs such as physical culture, manual training, carpentry, woodworking, sewing, and business education into the prescribed curriculum. Because of his openness to new approaches and receptivity to the

somewhat radical ideas promoted by Calista Jones and others, in the 1901 *Jamestown High School Annual*, Love was heralded as "a deep and liberal scholar . . . a prince among schoolmasters." For the same reasons, perhaps, he was appointed the first librarian of the James Prendergast Library, a position that required intelligence and sound educational management, and was also chosen to serve as president of the Chautauqua County Society of Natural History and Science.

FIRST CONGREGATIONAL CHURCH

FIRST CONGREGATIONAL CHURCH, ORGANIZED JUNE 16, 1816, JAMESTOWN'S FIRST RELIGIOUS SOCIETY, MET AT MAIN AND FIFTH STREETS WHERE A CHURCH BUILT IN 1829 SERVED UNTIL THIS GOTHIC EDIFACE WAS ERECTED IN 1869. THIS IS THE OLDEST CHURCH BUILDING IN JAMESTOWN.

JAMESTOWN CENTENNIAL COMMITTEE
STATE OF NEW YORK 1986

The First Congregational Church was organized in 1816 by circuit rider Rev. John Spencer. Worship was first held at the Old Academy Building, at North Main and Fifth Streets, after which property was purchased on East Third Street near Prendergast Avenue, the historic marker site of the first church in the settlement and the oldest city building in continuous use. From 1917 until 1944, Dr. Alfred E. Randell was the church's pastor as well as the director of the Department of Religion at the Chautauqua Institution. (Courtesy Jane Currie.)

The First Swedish Methodist Church, renamed Epworth United Methodist Church, was one of the city's earliest churches established by Swedish immigrants. Originally meeting in a private home on Center Street, the congregation eventually moved into their new building on Chandler Street and Foote Avenue, the hub of the Swedish religious community. Maria Bergwall from Stockholm began teaching Sunday school to children in a Tower Street home in 1869; her desire was that the children might learn "the rudiments of truth and . . . live a Christian's life." (Courtesy Kathleen Crocker.)

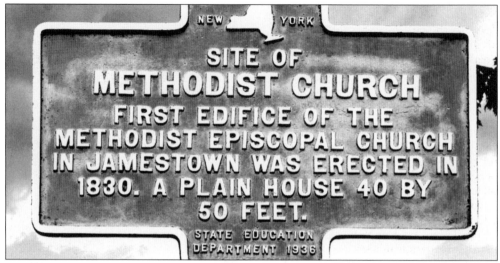

The historic marker site for the first Methodist church is at the corner of Chandler and Second Streets. Centrally located, the church with its lofty spire is readily identified in most photographs of downtown Jamestown. In addition to Methodist congregations, it also served the Unitarians for several years until the building was demolished to accommodate a new street pattern. (Courtesy Jane Currie.)

Since 1910, with Rev. James Carra of Buffalo as pastor, St. James Roman Catholic Church has been a focal point of the Italian community in Brooklyn Square. At one time, more than 2,000 attended the church and its adjacent school parish. This photograph of a St. James First Communion was taken on June 1, 1947. From left to right are the following: (front) Joseph Enserro and Michael Giunta; (back) Margaret Milioto Torres, Donna Mae Donato Peppy, and Providence "Prudy" Calimeri Campbell. (Courtesy Mike Giunta.)

In the *Betty Weakland Magazine*, the caption with this photograph reads, "Youthful Sky Pilot: Betty Weakland Child Evangelist Returns from Her First Airplane Ride When She Flew Over Washington Carrying Her Bible." Although she was a poised and sophisticated orator at a young age, Betty Weakland had a passion for childhood activities as well. Like most little girls, she loved *The Bobbsey Twins*, *Aesop's Fables*, and reading in general; her other interests included ice-skating, roller-skating, and playing the piano. (Courtesy *Betty Weakland Magazine*, May 1927.)

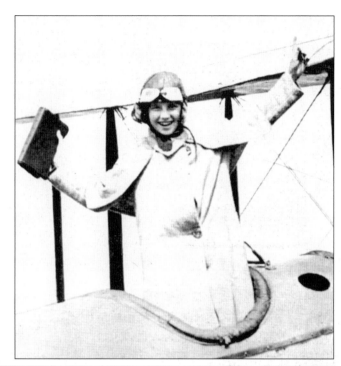

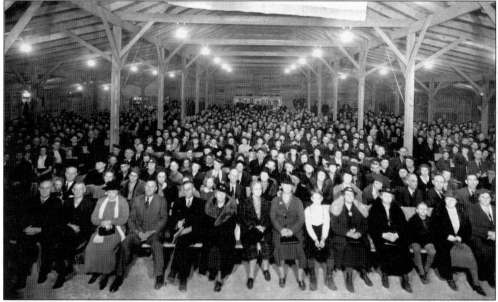

Born in Elmira in 1916, evangelist Betty Weakland shared the pulpit with her Baptist minister father during her childhood. At the age of four, she began to captivate audiences with her solos and Scripture-quoting and even spoke to an audience of 5,000 in Los Angeles. Returning to Jamestown, Weakland's followers and converts met in a custom-made wooden tabernacle after the Brooklyn Square skating rink proved too small a venue. Broadcast locally, her meetings grew increasingly larger during World War II. They were held at a schoolhouse on Camp and Maple Streets prior to the construction of the permanent Weakland Chapel, at 25 Camp Street near Allen Park. (Courtesy Betty Weakland.)

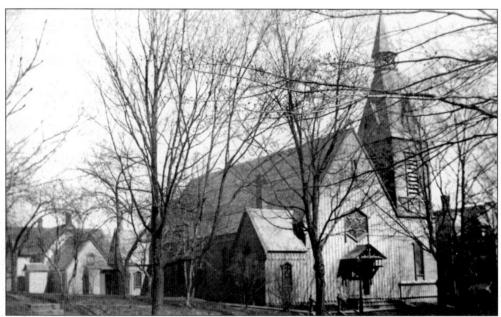

This *c.* 1885 photograph shows the old St. Luke's Church frame building before it was replaced by the new stone edifice, whose cornerstone was laid in 1892. British immigrant James W. Butterfield, a skilled weaver aware of the region's growing woolen industry, arrived in Jamestown and bought the two-story building for his family's residence. In 1893, the home was moved to Fairmount Avenue and Sixth Street near the boat landing, where it remained until razed in 1989. (Courtesy Jim Butterfield.)

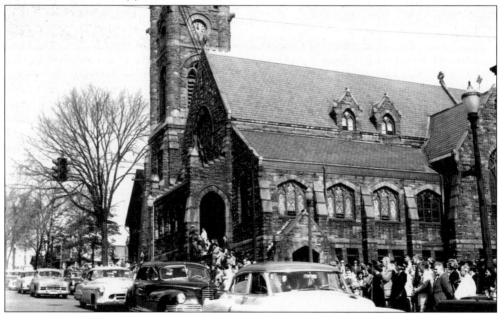

The body of Justice Robert H. Jackson lay in state here at St. Luke's Episcopal Church, at the corner of Main and Fourth Streets, prior to interment in the Maple Grove Cemetery in Frewsburg. Hundreds of mourners paid tribute to the country lawyer. (Courtesy Robert H. Jackson Center.)

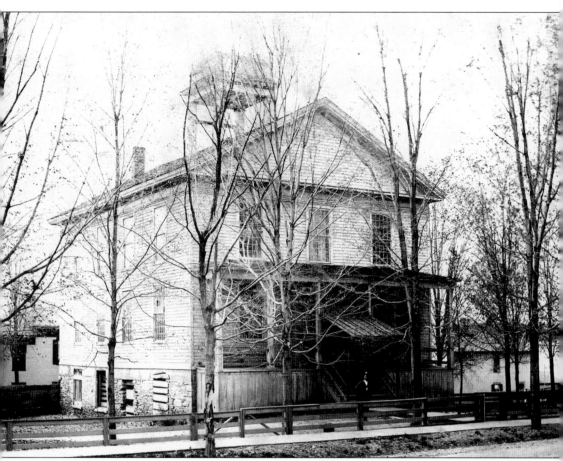

In 1816, city founder James Prendergast hired Israel Knight to erect a two-story building for educational purposes beyond the village limits. Known as the Prendergast Academy, the historic marker site on Main Street near Fifth was shared with the First Congregational Church until 1829. The second school building at Fourth and Pine Streets was erected in 1836. Many name changes and locations ensued. In 1897, the new high school building was thought to be rather avant-garde: "A work shop for manual training, finely equipped chemical and physical laboratories, a spacious gymnasium with accompaniments of lockers and shower baths, an interesting museum, a carefully selected library . . . all for a well-rounded education." Three years later, the school boasted "a competent physical director, manual training equipment . . . a course in the Swedish language and literature, a comprehensive commercial course, etc." (Courtesy Chautauqua County Historical Society.)

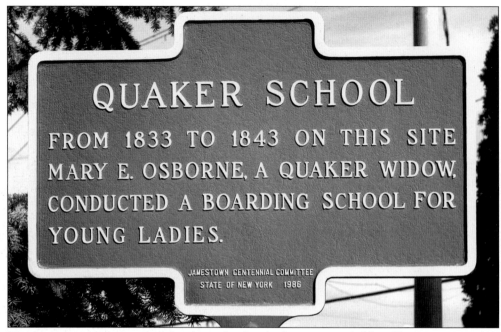

QUAKER SCHOOL

FROM 1833 TO 1843 ON THIS SITE
MARY E. OSBORNE, A QUAKER WIDOW,
CONDUCTED A BOARDING SCHOOL FOR
YOUNG LADIES.

JAMESTOWN CENTENNIAL COMMITTEE
STATE OF NEW YORK 1986

Two historic marker sites identify select schools, which were attended by affluent young women whose parents opted for a better education than that provided by the public school system. The Quaker School on Foote Avenue was headed by Mary E. Osborne from 1833 to 1843, and the Jamestown Female Seminary on North Main Street was founded by Clarissa D. "Dame" Wheeler, operating from 1849 until 1859. Both private boarding schools offered a basic curriculum along with a variety of courses, including the arts and French. (Courtesy Jane Currie.)

Calista Selina Jones (1823–1900) was an educator in Chautauqua County for more than 50 years. Despite male resistance, she courageously petitioned for free education for all young people. She also helped unify the individual districts; in 1887, her efforts resulted in the establishment of the Union Free School system. Phin Miller, in a county education document, wrote that Jones "was a fearless sergeant in command of the educational picket line in the struggle to subdue ignorance and vice. We honor ourselves when we sing her praises." She was also known as the pioneer suffragette, the first woman in Jamestown to exercise her right to vote. (Courtesy Chautauqua County Historical Society.)

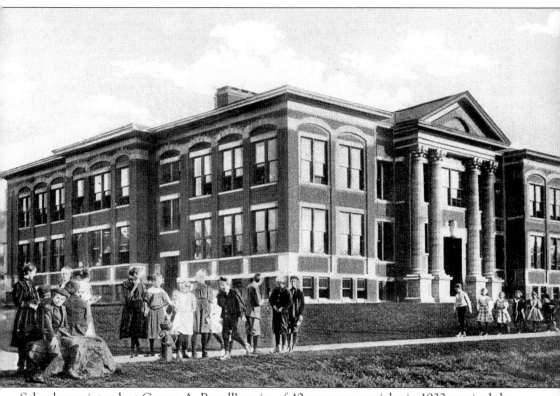

School superintendent George A. Persell's series of 40 newspaper articles in 1932 apprised the public of Jamestown's educational policies and procedure. The junior high school concept was essential, for example, to bridge the enormous gap between the lower and higher grades. Likewise, incorporating music into the elementary school classrooms such as those at South Side Grammar School was a means of teaching children to live in harmony with their peers. The new Jamestown High School, which occupied the site of the earlier group of four buildings first erected in 1867, was dedicated on November 15, 1935. The address was presented by former student the Honorable Robert H. Jackson, who at that time was the assistant general counsel of the U.S. Treasury Department. (Courtesy Kathleen Crocker.)

Established in 1950, Jamestown Community College (JCC) was integral to the community, as its name suggests. In 1951, it became the first of the community colleges in the State University of New York (SUNY) system to confer associate degrees in liberal arts. Its first campus, at the historic marker site at Foote Avenue and Allen Street, was located in the Fletcher Goodwill house donated by the Women's Christian Association Hospital. Committed to lifelong learning, the new campus was relocated in 1962 to its current site, on Falconer Street, and as expected, many JCC alumni are active in community affairs. (Courtesy Jane Currie.)

Jamestown Business College (JBC) was founded by E. J. Coburn, Esq., in 1886 and incorporated by the state of New York with the power to issue college diplomas three years later. This c. 1905 photograph shows a unique class at its School of Phonography, later called the School of Stenography, where shorthand, typing, correspondence, and office practice courses were taught. Note the system of tubes that permitted 12 students to be simultaneously connected to the Edison phonograph for dictation training. More than a century later, JBC continues to prepare its students for practical pursuits in the business community. (Courtesy Jamestown Business College.)

Eight

RECREATION AND THE ARTS

Jamestown and the surrounding Chautauqua Lake region abound with recreational activities. Residents and visitors alike may enjoy indoor and outdoor activities throughout the year. Nearby woodlands, meadows, hills, rivers, streams, and, of course, Chautauqua Lake are conducive to a multitude of sports and individual pastimes, which include boating, swimming, fishing, camping, hunting, skating, skiing, snowmobiling, ice fishing, tennis, baseball, hiking, and so on.

City playgrounds and parks maintain ball fields, tennis courts, hiking trails, slides and swings, picnic facilities, and concert band shells during the summer months. Since its opening in 2002, the state-of-the-art Jamestown Savings Bank Ice Arena has provided countless hours of pleasure for hockey players, figure skaters, and recreational skaters of all ages.

Exceptional talent and teachers like Samuel Thorstenberg and Ebba and Arthur Goranson laid the foundation for the music programs in the public school system. Many students who trained to participate in the A'Cappella Choir and the high school marching band have continued their musical careers as members of the Jamestown Choral Society, the Chautauqua Chamber Singers, church choirs and choruses, bands, and orchestras. The proximity of the prestigious music programs at the State University of New York at Fredonia and at the Chautauqua Institution's School of Music has further enriched the area.

Beginning with vaudeville, local audiences have been fortunate to have several resident theater companies in town, including the Players Club, the Shoestring Players, and Little Theater. Ballet companies, films, galleries, and performers invited to the city by the Jamestown Concert Association have also entertained and educated thousands of area citizens. These exceptional cultural offerings are unequaled in many more populated cities. Both professional and amateur musical and dramatic performances attract full houses. During a typical weekend, it would be impossible to attend all of the available productions in Jamestown—a positive dilemma, for sure.

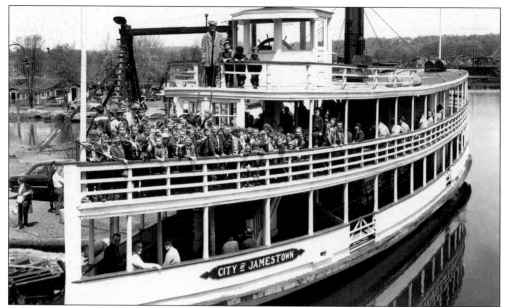

The *City of Jamestown* steamer, jam-packed with Boy Scouts, appears ready to embark from the boat landing on an excursion to either Celoron or Midway Amusement Park for a day of picnic and pleasure. Beginning in 1828, a fleet of steamboats wound its way from its boat landing berths near Fairmount and Eighth Street through the swampy outlet to destinations around Chautauqua Lake. Summer visitors who arrived in Jamestown by train from Buffalo and Pittsburgh were transferred at this location onto steamers to various lakeside resorts. (Courtesy *Post-Journal*, Jamestown.)

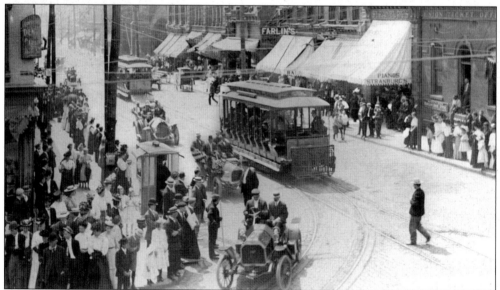

This downtown scene captures a horse and buggy, touring cars, and electric trolley cars—all transporting passengers to a variety of places both in the city and around Chautauqua Lake. On his 81st birthday in 1900, William Broadhead was praised for "providing for our citizens means of transportation and opportunities for recreation and enjoyment that have contributed to our comfort and happiness." (Courtesy Sydney S. Baker.)

The 32-acre Allen Park, near Jefferson Middle School, was gifted to the city in 1909. Its ravine, meadow, and brook provide an idyllic setting for picnics, nature walks, sledding, skiing, bobsledding, baseball, tennis, and indoor skating. In 1922, the parks department reported annual attendance: 16,000 at band concerts; 9,000 at ball games; and 15,000 picnickers and park visitors. A favorite park attraction remains the free open-air concerts performed by the Jamestown Choral Society, the Imperial Band, and many other musicians. In 1967, the Goranson Bandshell was dedicated to honor Arthur and Ebba Goranson, siblings and "co-architects . . . of the splendid . . . choral and instrumental music in the Jamestown public schools." (Courtesy Edward Schaefer.)

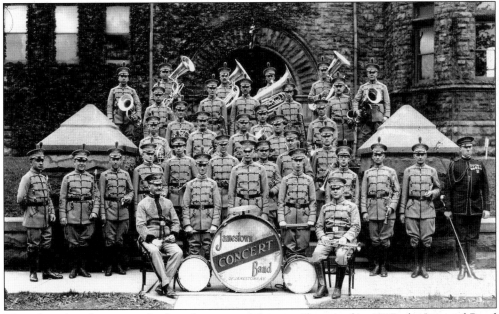

Music has played an integral role in Jamestown's history. Organized in 1910, the Imperial Band was founded by Italian immigrants; its Swedish counterpart was the Corona Band. Both groups played at church celebrations, in parades, and on the lake steamers. Posed before the beautiful James Prendergast Library building, a popular backdrop for group photographs, is the Jamestown Concert Band, which also helped instill in residents a love and appreciation of music. (Courtesy James Prendergast Library Association.)

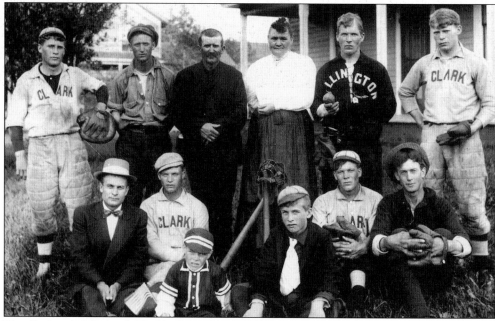

BASEBALL

AN ENDURING PART OF JAMESTOWN'S HERITAGE

THIS MARKER RECOGNIZES THE BASEBALL PLAYERS AND SPECTATORS OF YESTERYEAR AND SALUTES THE PRESENT AND FUTURE PLAYERS AND FANS.

PLACED BY THE JAMESTOWN
HISTORICAL MARKER COMMITTEE
AND THE CHAUTAUQUA SPORTS
HALL OF FAME, 1991

This historic marker site is located at 285 Falconer Street, near the entrance to Diethrick Stadium. Many major-league careers were launched by players' participation in the Pennsylvania, Ontario, and New York (PONY) League, whose games were played in Jamestown beginning in 1939. Considered a hotbed for professional baseball, local fans have had easy access to exceptional teams. (Courtesy Jane Currie.)

The Becker brothers of Clark's Corners, east of Jamestown, entertained many Chautauqua County baseball fans during the early 1900s at baseball games in Jamestown, Frewsburg, Gerry, Falconer, and Ellington. From left to right are the following: (front) Marvin and Elton; (middle) Pete, manager Jess, Lewis, and Tom DeForest; (back) George, Fred, father Austin, mother Jenny, Frank, and Joe. Austin Becker served as manager for the unique all-brother team, the only family club in the area. All of his boys could play any position in the infield or outfield, as well as pitch. Although they were invited to play on the road to barnstorm, the Beckers declined the offers in order to tend the family farm and to hunt. (Courtesy Becker family.)

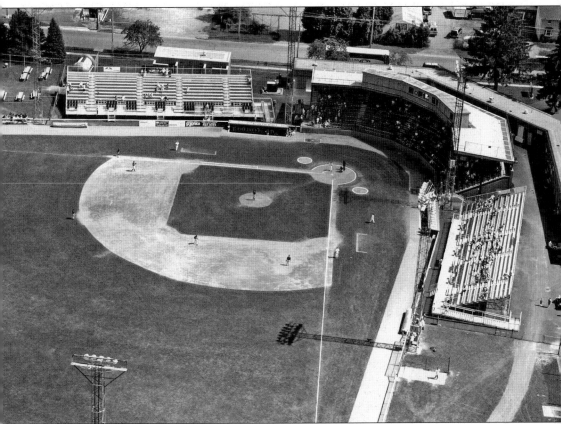

Jamestown amateurs, semipros, and professional baseball players used several venues in the early years of the game, including Allen Park and Celoron Park, where most of the barnstorming games were held until the late 1930s. After the completion of the 4,200-seat municipal stadium in 1941, Jamestown became the farm club for the Detroit Tigers, Atlanta Braves, Boston Red Sox, Montreal Expos, Pittsburgh Pirates, and Buffalo Bisons. Russell E. Diethrick Jr. Park was named to honor a man who has been an asset to the community in numerous endeavors. With the assistance of Greg Peterson, another devoted local baseball fan, Diethrick headed a campaign to raise sufficient funds to meet major-league mandated improvements for the stadium and ball field. One result is that Jamestown has been honored to host the Babe Ruth World Series for 13- to 18-year-old players, attracting youths and fans from all over the country. (Courtesy Pamela Berndt Arnold and pilot Jim Nohlquist.)

"ALLEN'S OPERA HOUSE"

1881 Allen's Opera House

1898 Samuels Opera House

1919 Shea's Opera House/Theater

1968 Little Theatre of Jamestown

Little Theater, an outgrowth of Allen's Opera House, became a competitor of the Palace Theater on East Third Street (later the Dipson's Palace Theater) with its 2,000 seat auditorium. When poor attendance forced the Palace to close, individual patrons and local agencies advocated its restoration, and as a result, the theater reopened in 1982. The Reginald and Betty Lenna Foundation's $1 million pledge enabled the totally renovated Reg Lenna Civic Center to became a reality in 1990. Dedicated to active community citizenship, the cultural center hosts graduation ceremonies, church services, and an array of community events, in addition to first-class theater productions. (Courtesy Jane Currie.)

In his detailed history of the Swedes of Jamestown, M. Lorimore Moe provided a colorful recollection from his youth about "the Greatest Show on Earth." He remembered that everyone gaped at "the flamboyant circus wagons in gaudy gilt and glitter. . . . Clowns, acrobats and fancy riders sat astride the huge draft horses. . . . We shivered with excitement as glowering leopards, lions and tigers paced their wheeled cages only feet in front of us. A smoke-belching, coal-fired steam calliope brought up the rear." Such was the thrill during this circus parade c. 1890. (Courtesy Sydney S. Baker.)

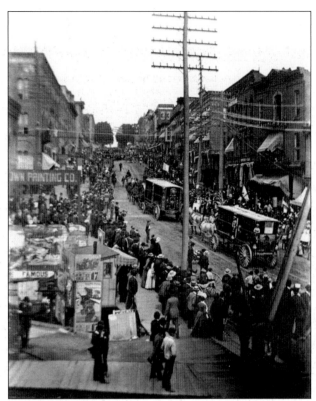

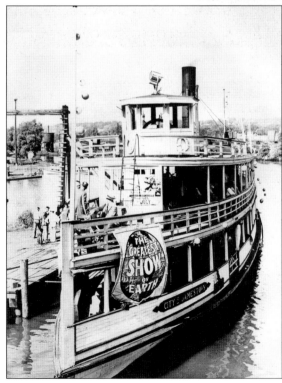

Circuses performed under the big top in east Jamestown near Falconer, although banker S. Henning Swanson remembered one held near the old Sherman Street school, according to Moe's *Saga from the Hills*. The *City of Jamestown* moored at the boat landing c. 1950 displayed advertisements indicating that area children were in for another treat that July. (Courtesy Winton "Ed" Edwards.)

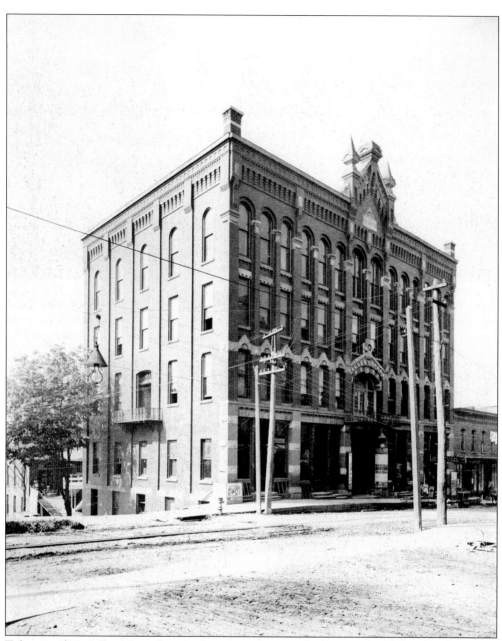

Talents such as Lillian Russell and John Philip Sousa appeared on the stage of Allen's Opera House, a historic marker site, built in 1881 at East Second Street and Pine. Theatergoers, however, are more familiar with its replacement, Little Theater. During the mid-1940s, Jamestown had the distinction of being the home of the largest Little Theater in the country. By 1946, its membership totaled more than 5,000 subscribers, a local and national record. Local theater legend Samuel Paladino chaired the steering committee and fund drive that enabled Little Theater to find a permanent home in the vacant Sheas's Theater in 1968, believing that "the theater will give Jamestown one of the finest cultural assets in the entire country." The theater's versatile Lucille Ball Junior Guilders troupe has performed throughout the United State and abroad in recent years. (Courtesy Sydney S. Baker.)

Doris Phillips Wilbur, a music supervisor in the Jamestown schools, made her first Little Theater appearance in the 1929 production of *Fashion*. She continued her acting career until the age of 80, when she appeared in *My Fair Lady*. Wilbur believed, as do many actors, that although she gave much of herself to the theater, the theater gave as much or more to her. (Courtesy Jane Currie.)

This scene from *Sabrina Fair* was presented by Little Theater in March 1955 at the Scottish Rite Temple, now the Robert H. Jackson Center. On stage from left to right are William Broadhead, Max Robinson, Doris Wilbur, Samuel Paladino, and Howard Crossley. Since Little Theater had no playhouse, the group rented the converted carriage house for the performances. Organized in 1920, the Players Club opened the Chautauqua Institution's theater season for several years and often performed for local charity events. (Courtesy Samuel Paladino.)

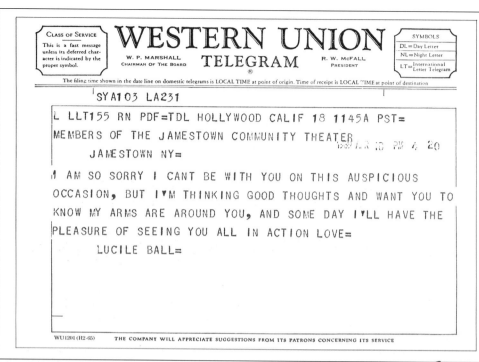

SYA103 LA231

L LLT155 RN PDF=TDL HOLLYWOOD CALIF 18 1145A PST=

MEMBERS OF THE JAMESTOWN COMMUNITY THEATER

JAMESTOWN NY=

I AM SO SORRY I CANT BE WITH YOU ON THIS AUSPICIOUS
OCCASION, BUT I'M THINKING GOOD THOUGHTS AND WANT YOU TO
KNOW MY ARMS ARE AROUND YOU, AND SOME DAY I'LL HAVE THE
PLEASURE OF SEEING YOU ALL IN ACTION LOVE=

LUCILE BALL=

In 1946, when she received the symbolic key to her hometown, Lucille Ball was invited by members of Little Theater to be the guest of honor on their annual boat ride on the *City of Jamestown*. Ball sent this telegram to theater members on April 18, 1969. Since her own career had begun with the Players Club, Little Theater was aptly renamed the Lucille Ball Little Theater in 1991. At its dedication, former director Donald Lynn praised Ball's influence on Jamestown's drama community: "Her bright light will help guide the footsteps of generations of entertainers to come." (Courtesy Samuel Paladino.)

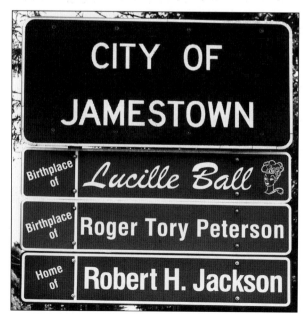

As people approach the city limits, they are alerted by this sign that three of the most renowned individuals of the 20th century had their humble beginnings in Jamestown. (Courtesy Jane Currie.)

Nine

FAMOUS NATIVE
DAUGHTER AND SONS

Although they rose to the pinnacles of their careers in dramatically different fields, the lives of Lucille Ball (1911–1989), Roger Tory Peterson (1908–1996), and Robert H. Jackson (1892–1954) bore a close resemblance.

In addition to attending local public schools, they all became interested in their particular specialties while residing in the area, were supported and encouraged by community members, attained global status, and received innumerable prestigious honors and awards.

Despite their fame, however, all three celebrities retained lifelong associations with family, friends, business associates, and the community in general. Although they did not reside in Jamestown as adults, they were warmly welcomed back during their return visits. More significantly, the honor of permanently housing and preserving their precious legacies was bestowed upon their hometown. Visitors from around the world have had the opportunity to visit the Lucille Ball-Desi Arnaz Center, the Roger Tory Peterson Institute of Natural History, and the Robert H. Jackson Center—all located in the heart of Jamestown.

All three cared deeply for their childhood community and its citizens. Lucille Ball made the following public tribute on a trip back home in 1946, and perhaps Peterson and Jackson felt somewhat the same: "They'll tell you that California is God's country, but God's country is right here in Jamestown. Think of the change of seasons, the gardens, the mushrooms, lilacs blooming in the spring—it's a wonderful, wonderful place, Jamestown, Celoron, the lake—that's why I had to come back."

Back the trio came to eternal rest in pastoral settings. In spite of their international stature, they all returned home. At her children's request, Ball was recently transferred from a California grave site to the Hunt Lot in Lakeview Cemetery. Peterson's resting place is in Pine Hill Cemetery in Falconer. Jackson's is in Maple Grove Cemetery in Frewsberg. What an honor for Jamestown.

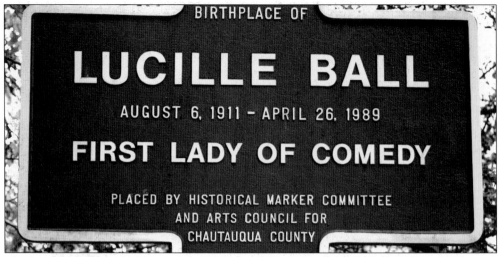

BIRTHPLACE OF

LUCILLE BALL

AUGUST 6, 1911 – APRIL 26, 1989

FIRST LADY OF COMEDY

PLACED BY HISTORICAL MARKER COMMITTEE
AND ARTS COUNCIL FOR
CHAUTAUQUA COUNTY

This historic marker site is located on East Second Street beside the Lucille Ball Little Theater. After her introduction to theater in Jamestown, Ball's professional career began in New York City at the age of 15, prior to her departure to the West Coast where she attained stardom. Among her innumerable honors were four Emmy Awards and the Presidential Medal of Freedom in 1989, the country's highest civilian honor. (Courtesy Jane Currie.)

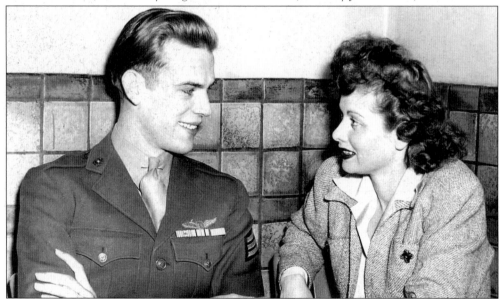

While recuperating from a World War II injury, Marine Sgt. Lawrence W. Eddy from Jamestown met Lucille Ball in the naval hospital in Corona, California. In 1944, when Ball attended Grandpa Fred Charles Hunt's funeral in Jamestown, she decided to invite Eddy as her escort to various fund-raisers. She sold war bonds at civic clubs, churches, the furniture expo trade show, the rally in the high school gym, and amazingly raised $8,000 in one appearance at the Marlin Rockwell Company. In this rare photograph, the pair took a break in the Hotel Jamestown coffee shop. Eddy, who now lives in Vancouver, Washington, has fond memories of that experience. After the funeral, Ball left for Philadelphia to sell more war bonds. Throughout her life, Ball made generous donations to numerous Jamestown organizations. (Courtesy Lawrence W. Eddy.)

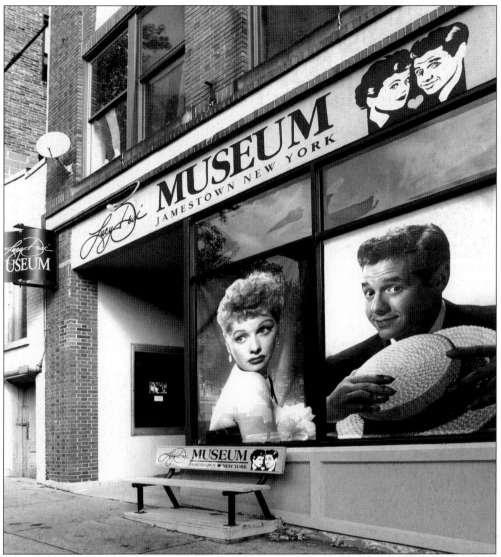

The Lucille Ball-Desi Arnaz Center on Pine Street was established in 1996 to commemorate Jamestown's "most famous daughter and adopted son." Its stated mission is "to keep alive the memory, celebrate the legacy, and preserve the personal effects and professional works of Lucille Ball and Desi Arnaz and, by so doing, enrich and strengthen the place Lucy called home." Although relatively small space-wise, its interactive exhibits entertain thousands of visitors each year who come from all states and several foreign countries, especially during the annual celebrations held Memorial Day weekend and for Lucy's Birthday Celebration in August. As of the summer of 2003, more than 90,000 visitors from 36 countries have visited the museum. Clothing, personal photographs, memorabilia, and histories have been donated by Lucy and Desi's children, Lucie Arnaz and Desi Arnaz Jr., who hold Ric Wyman, the museum's executive director, and his staff in high regard. Following their latest donation of Lucy's "Wildcat" wig and Desi's smoking jacket, Lucie Arnaz told reporters: "I know they [the artifacts] will be protected over time so many more people, who loved our parents almost as much as we did, will be able to experience a little bit more of the very human and personal sides of them." (Courtesy Jane Currie.)

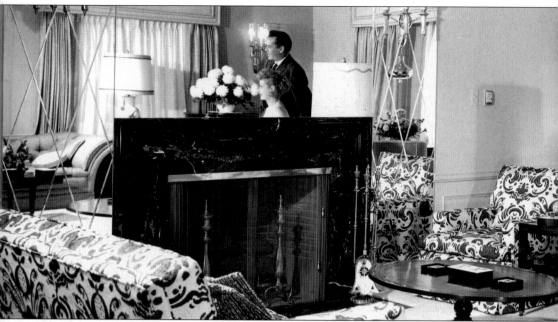

Although she lived on the West Coast, Lucille Ball was aware of Jamestown's fine furniture and patronized Jamestown businesses. When she and Desi Arnaz moved into a new home in California, they ordered their bedroom and dining room suites from Union National Furniture Company and sofas, chairs, and love seats for their living room, seen above, from Jamestown

On February 7, 1956, the Jamestown *Post-Journal* headline read, "Lucy and Desi Take City by Storm." In town for the world premiere of their movie *Forever Darling*, the couple landed behind Jamestown High School in a Bell Aircraft helicopter and were met by a cheering crowd of several thousands. Covered by local and national press, a whirlwind of activities, in addition to the film at Dipson's Palace Theater, ensued. A homecoming parade and dance were held to benefit the Jamestown General Hospital Auxiliary. The couple visited the children's ward at the hospital, and upon learning that the youngsters had no television to view the *I Love Lucy* show, they made arrangements for one to be immediately installed. Donned in a fluff of fur, Ball was escorted to the theater by Bill Taylor of the Chautauqua County Sheriff's Department and other officials. (Courtesy *Post-Journal*, Jamestown.)

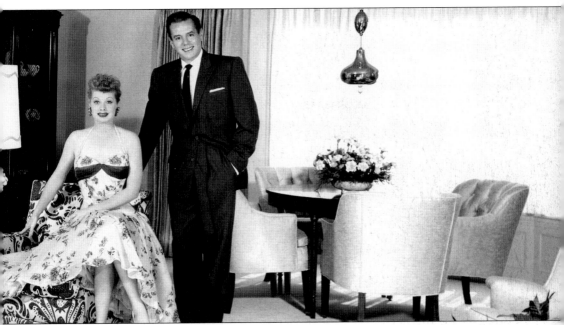

Royal Furniture. Arrangements were made with the company presidents, Alldor M. Nord and Earl O. Hultquist, respectively, to transport the merchandise to their home by chartered plane. (Courtesy Jamestown Royal Furniture Company Inc.)

Prior to the premiere, the president of Jamestown Royal Furniture hosted a cocktail party and buffet supper in the company's showroom to honor the actress and her husband. From left to right are company president Earl O. Hultquist, Desi, Lucy, Mrs. Earl Hultquist, and Mr. and Mrs. Alldor Nord. In honor of the occasion, the company designed a *Forever Darling* chair to feature in its catalog. (Courtesy Jamestown Royal Furniture Company Inc.)

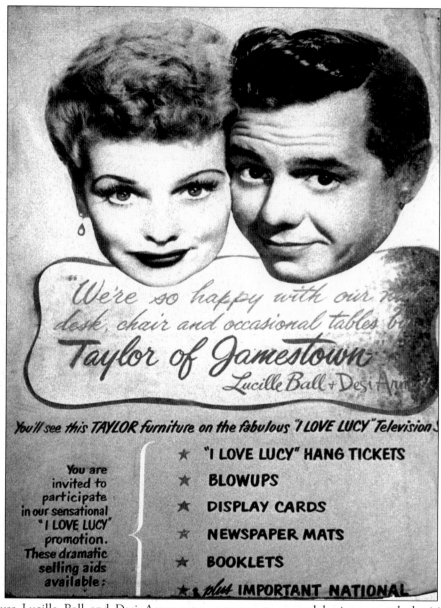

"We're so happy with our n___ desk, chair and occasional tables b__ *Taylor of Jamestown*"
Lucille Ball + Desi Arn___

You'll see this TAYLOR furniture on the fabulous "I LOVE LUCY" Television S___

You are invited to participate in our sensational "I LOVE LUCY" promotion. These dramatic selling aids available:

★ "I LOVE LUCY" HANG TICKETS
★ BLOWUPS
★ DISPLAY CARDS
★ NEWSPAPER MATS
★ BOOKLETS
★ *plus* IMPORTANT NATIONAL

Because Lucille Ball and Desi Arnaz were generous to several businesses and charities in Jamestown, these organizations, in turn, benefited from the pair's celebrity status, as evidenced in this Taylor Furniture Company advertisement. To honor Jamestown's revered couple, artist Gary Peters received permission from CBS Inc. and Desilu, too LLC to replicate two scenes from the successful *I Love Lucy* series on downtown buildings. The larger-than-life murals created with acrylic paints are eye-catchers and neck-breakers, especially for out-of-town visitors who readily recognize Lucy in the famous candy factory scene and as the saleswoman for Vitameatavegamin. The third facsimile, located on the side of the federal building, is of a postage stamp featuring Lucy and Desi, issued in 1999 as part of the Celebrate the Century stamp series. Due to copyright laws, the images were unavailable for reproduction in this publication; instead, readers must visit Jamestown in order to appreciate them. (Courtesy *Post-Journal*, Jamestown.)

Lucille Ball lived with her grandparents Flora Belle and Fred Charles Hunt for most of her childhood. According to the *1895–1896 City Directory*, Grandpa "Daddy" Hunt resided on Warren Street (now South Main) and, like many other residents, worked in the furniture industry. Not surprisingly, he whittled toys and made doll furniture for all of his grandchildren. Ball, her mother, and brother Fred all lived together with the Hunts for a time in Celoron, not far from the amusement park with which Ball became enchanted. (Courtesy Arnaz family.)

BALL
LUCILLE

TELEVISION AND MOVIE STAR

Born – Jamestown, NY August 6, 1911
Died – Los Angeles, Calif. April 26, 1989

LUCY'S FAMILY

"DeDe" Hunt Ball – Lucy's Mother
Henry Ball – Lucy's Father
Fred & Florabelle Hunt – DeDe's Parents
Lola Hunt – DeDe's Sister
Harold Hunt – DeDe's Brother
Reuben & Eveline F. Hunt – Fred's Parents

Lucille Ball was not only the consummate performer, known primarily for the *I Love Lucy* television series which became *The Lucille Ball-Desi Arnaz Show*, but also "one of the television industry's most influential leaders," according to author Elisabeth Edwards. "In 1962, when Desi retired from Desilu Studios, Ball became the first female president of a major Hollywood film producing company." Yet, Lucy, whose reruns may be seen at any time somewhere around the world, brought the world the gift of laughter. That, believes Edwards, is her greatest legacy: "the laughter, which her memory continues to generate in her fans, both old and young, throughout the world." (Courtesy Jane Currie.)

This historic marker site is in front of 16 Bowen Street, the home of Roger Tory Peterson. His many credits are listed on the sign. However, Arthur Klebanoff, a former board president of the Roger Tory Peterson Institute of Natural History, made the astute observation that Peterson himself "was a window to the natural world and, for many, a defining influence." (Courtesy Jane Currie.)

James M. Berry, president of the Roger Tory Peterson Institute of Natural History, provides this all-encompassing tribute to his mentor: "The combination of a young Roger Tory Peterson's passionate interest in all things wild and his insightful seventh grade teacher who encouraged curiosity and investigation in all her students produced perhaps the world's greatest interpretive naturalist. Roger devoted his life to creating art, books, and photographs about plants and animals (especially birds) for the ordinary person." (Courtesy Roger Tory Peterson Institute of Natural History.)

Photographed in Roger Tory Peterson's studio in Old Lyme, Connecticut, this image emphasized his artistic skills. Born in 1908, Peterson grew up in Jamestown and, at age 11 with the encouragement of his seventh-grade teacher, Blanche Hornbeck, he joined the Junior Audubon Club, which she had organized. After graduating from Jamestown High School in 1925, Peterson moved to New York City to study at the Arts Student League. From 1929 until 1931, he perfected his artistic skills at the National Academy of Design. In 1980, Pres. Jimmy Carter conferred upon Peterson the Presidential Medal of Freedom, the highest of civilian awards, which is on display in the Jamestown museum. (Courtesy *Post-Journal*, Jamestown.)

Founded in 1984, the Roger Tory Peterson Institute of Natural History became permanently housed on Curtis Street in 1993. Located on 27 acres, designer Robert A. M. Stern of New York City "had in the back of [his] mind the tremendous Scandinavian heritage that Peterson represents and the wooden buildings one finds in Sweden and Norway." In 1998, the lower Swedish flag was presented to the institute by Norma Baker Larson in memory of her childhood classmate. (Courtesy Roger Tory Peterson Institute of Natural History.)

In the 1930s, Roger Tory Peterson was the education director at the National Audubon Society in New York City. The Jamestown chapter of the society was founded in 1957 on a 214-acre lot south of the city on Riverside Drive. Fittingly, Peterson was invited to break ground for the construction of the Roger Tory Peterson Natural Interpretive Building at its dedication here in August 1976. His close friend M. Lorimore Moe, a journalist, believed the new facility would "serve the community as a real teaching instrument in the field of nature and ecological studies." (Courtesy *Post-Journal*, Jamestown.)

"WE, ALONE OF ALL CREATURES, HAVE IT WITHIN OUR POWER TO RAVAGE THE WORLD OR MAKE IT A GARDEN."

ROGER TORY PETERSON

DEDICATED OCTOBER 16, 1976
BY
JAMESTOWN AUDUBON SOCIETY, INC.

The Jamestown chapter Audubon Nature Center's offerings provide environmental awareness for youth and adults in a vibrant outdoor setting. Visitors have benefited from the research library, exhibits, educational programs, hands-on Discovery Room, and Burgeson Wildlife Sanctuary, honoring botanist O. Gilbert Burgeson, who helped organize the Allegany Nature Pilgrimage in the nearby state park. Inscribed on a boulder near the center's entrance is the above admonition from Roger Tory Peterson. (Courtesy *Post-Journal*, Jamestown.)

Roger Tory Peterson is seen holding a scrub jay in his right hand and a copy of the classic for birders, *A Field Guide to the Birds*, in his left. In 1934, after much deliberation, the Houghton-Mifflin Company published 2,000 copies of the guide written and illustrated by Peterson. According to the guide's dust jacket, the drawings of 440 different species of birds have enabled people to quickly and accurately identify and differentiate bird species with the use of this "simple, convenient, complete . . . bird guide [that] emphasizes the characteristics of birds 'when seen at a distance.' " This innovation was one of Peterson's greatest accomplishments: the development of a bird-identification system for the layperson. His field guide is considered to be one of the most revolutionary developments in the history of American birding, and 70 years later, more than 15 million copies have been sold in the United States and abroad. Replacing more technical guides, the Peterson system allows nearly instant recognition of a bird's distinctive and unique characteristics. (Courtesy Linda Westervelt.)

An elegant brick structure at the corner of East Fourth Street and Prendergast Avenue, the Robert H. Jackson Center has a fascinating history. To focus national attention on the newly formed Chautauqua Assembly at the opposite end of the lake, cofounder John Heyl Vincent sought a person of stature to attend its second session in 1875. Since Pres. Ulysses S. Grant had been one of Vincent's parishioners in Galena, Illinois, the latter accepted his friend's invitation. En route to the Chautauqua grounds, the soldier-president dined at this home, built for Jamestown banker Alonzo Kent. Before heading up the lake in the *Josie Bell*, Grant and his host, Alonzo Kent, rode to the boat landing in a phaeton drawn by a handsome team of black horses. Townspeople of all ages ran alongside to glimpse the country's leader who visited their city. Grant's visit set a precedent for future U.S. presidents, 10 of whom have visited the Chautauqua Institution before, during, or after their term of office. In the 1920s, the Scottish Rite Bodies bought the Kent mansion to house the Scottish Rite Consistory. Purchased from the Masons in 2001, it has since attained worldwide recognition as the Robert H. Jackson Center, dedicated in 2003 by William H. Rehnquist, the chief justice of the U.S. Supreme Court. (Courtesy Jane Currie.)

William Jackson owned a hotel, sawmill, and livery stable in Spring Creek, Pennsylvania, where his son Robert was born. When the Jacksons moved to rural Frewsburg, horse breeding and horse racing continued to be a family passion. Jackson's natural affinity for horses lasted throughout his life. This serene setting, with Chautauqua Lake in the background, illustrates a leisurely ride with his wife, Irene Gerhardt Jackson, astride Gray Goose, and Jackson on Blue Bonnet. (Courtesy Robert H. Jackson Center.)

This formal Jackson family portrait of daughter Mary, wife Irene, Robert, and son Bill was taken in 1954. On March 2 of that year, an article in the Jamestown *Evening Journal* mentioned that Mrs. Robert H. Jackson was considered a "possible future 'First Lady of the Land' since Attorney General Jackson is frequently mentioned as a possible Democratic nominee for president." John Q. Barrett, the esteemed Jackson scholar, acknowledged that Jackson was one of Franklin D. Roosevelt's "key assistants and personal favorites" and would, no doubt, have been a presidential candidate had Roosevelt declined another term. (Courtesy Robert H. Jackson Center.)

After high school, Robert H. Jackson spent only one year, 1911 to 1912, enrolled in higher education at Albany Law School, yet successfully passed the New York State bar examination at the age of 21. He returned to Jamestown to serve an apprenticeship with lawyers Frank Mott and Benjamin Dean and was soon recognized as Jamestown's leading lawyer and a major force in the bar of Western New York. Some of his associations included memberships in Moon Brook Country Club, the Sportsmen's Club, and the Elks. Coauthor Jane Currie, a professional photographer, was delighted to discover that Robert H. Jackson was also a camera buff. (Courtesy Robert H. Jackson Center.)

During his fourth visit to the nearby Chautauqua Institution, on August 14, 1936, Franklin D. Roosevelt used the Chautauqua platform to deliver his famous "I Hate War" speech. Afterward, Roosevelt, Chautauqua president Arthur E. Bestor, and Robert H. Jackson rode to Bestor's home for a reception. Author William E. Leuchtenburg proclaimed Bestor's guests to be "two of the movers and shakers of the past century." (Courtesy Chautauqua Institution Archives.)

Selected in 1945 to serve as the chief counsel at the International Military Tribunal for the prosecution of Nazi war criminals, country lawyer Robert H. Jackson proved to be a credit to all Americans and to the Allied powers. His oratorical prowess was obvious in his opening remarks to the Nuremberg tribunal. In his lengthy and convincing statement, Jackson stated the trial's purpose with clarity and dignity; his logic quelled the fears of Europeans, indicating to them that the proceedings would be a democratic trial rather than a lynching of the captured Nazis.

During a eulogy at the nation's capitol, Supreme Court Chief Justice Earl Warren epitomized Jackson as an "able lawyer, statesman and jurist, his passing leaves a great void in this court. We shall miss greatly his wise counsel, his clarity of expression and his genial companionship." This Pennsylvania private railroad car transported the remaining eight associate justices of the U.S. Supreme Court to Warren, Pennsylvania, south of Jamestown, on October 13, 1954, to attend the funeral service of their colleague, the Honorable Robert H. Jackson. It was the only time that all of the Supreme Court justices were absent from the nation's capitol. (Courtesy Robert H. Jackson Center.)

Cartoonist Bradley A. Anderson, a member of the Scottish Rite Valley of Jamestown and the creator of *Marmaduke*, took the liberty of placing a Masonic hat on his beloved Great Dane. The drawing, which hangs in the upstairs hallway of the Robert H. Jackson Center, is captioned: "Marmaduke adds something BLUE to his wardrobe." (Courtesy Valley of Jamestown, AASR.)

Marmaduke's headpiece is similar to the bona fide one with the 33rd-degree jewel presented to Robert H. Jackson by the Jamestown Consistory, Ancient Accepted Scottish Rite of Freemasonry, after 32nd degrees were conferred upon 150 candidates in the Robert H. Jackson Class on May 10, 1951. Jackson and nearly 200 members of his class of 1930 attended the annual spring reunion at the consistory, where both the hat and sketch are on display. (Courtesy Valley of Jamestown, AASR.)

One of Jamestown's most community-minded men, attorney Greg Peterson has evidenced a contagious enthusiasm for the accomplishments of Robert H. Jackson and has been a powerful force in the creation and growth of the Jackson Center itself. As its president, Peterson is adamant about Jackson's importance on a global scale: "The Robert H. Jackson Center is designed to preserve the legacy of Justice Robert H. Jackson, the Chief American Prosecutor at the Nuremberg trials. Current events [2003] have shown that the story of Jackson is not just history revisited but real and relevant to our discussion of international justice and the rule of law." (Courtesy Robert H. Jackson Center.)

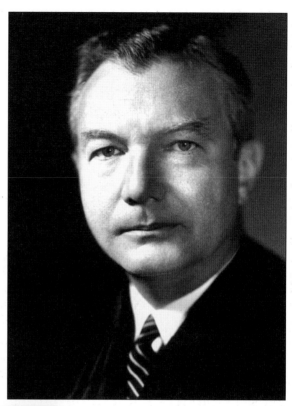

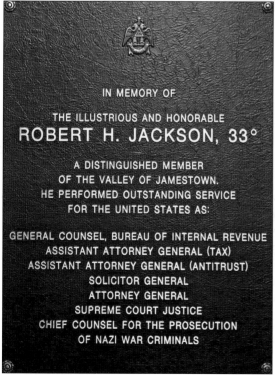

IN MEMORY OF

THE ILLUSTRIOUS AND HONORABLE
ROBERT H. JACKSON, 33°

A DISTINGUISHED MEMBER
OF THE VALLEY OF JAMESTOWN.
HE PERFORMED OUTSTANDING SERVICE
FOR THE UNITED STATES AS:

GENERAL COUNSEL, BUREAU OF INTERNAL REVENUE
ASSISTANT ATTORNEY GENERAL (TAX)
ASSISTANT ATTORNEY GENERAL (ANTITRUST)
SOLICITOR GENERAL
ATTORNEY GENERAL
SUPREME COURT JUSTICE
CHIEF COUNSEL FOR THE PROSECUTION
OF NAZI WAR CRIMINALS

Local historian Ernest D. Leet paid homage to Robert H. Jackson: "He [Jackson] was loyal to his friends, his associates, to his ideals, and to his profession . . . an expert trial lawyer, resolved that all persons should have equal standing before the law, and dedicated to the principle that our constitutional liberties should be preserved against intolerance, bigotry, hysteria or political pressure." Precedents set by Jackson will, no doubt, impact future opportunities to test individual liberties in military tribunals. (Courtesy Jane Currie.)

1810

Nationally syndicated in more than 500 newspapers, cartoonist Brad Anderson is best known for the creation of the beloved canine Marmaduke. Anderson became a brother in the Scottish Rite Valley of Jamestown in 1960, the same year his visual timeline (above) was headlined in the sesquicentennial edition of the *Post-Journal*. From left to right, the growth of Jamestown is chronicled from 1810 to 1960. Anderson's drawing serves as an overview of this book's content, highlighting the development of commerce and industry, the increase in population, and the improved modes of transportation. Although Jamestown's sesquicentennial was celebrated in grand style, more momentous occasions were just around the bend. For example, to help celebrate the nation's bicentennial in 1976, the reigning King of Sweden, His Majesty Carl XVI Gustaf, and his entourage chose Jamestown as one of a handful of cities to visit in the United States to

honor the region's hardy band of Swedish settlers. The king was welcomed by a throng of more than 7,000 citizens at Tracy Plaza. The previous year, Roger Tory Peterson had presented the monarch with a copy of his *Field Guide to the Birds*. During this visit, King Carl XVI Gustaf reciprocated by presenting Peterson with the *Linne-medaljen*, a prestigious honor bestowed by the Swedish Academy of Sciences. Two months later, Mayor Steven B. Carlson presented a key to the city of Jamestown to visiting Albanian royalty exiled King Leka, Queen Susan, and the Queen Mother Geraldine. When the village of Jamestown was incorporated in 1927, historian A. W. Anderson declared that "a new civic consciousness possesses the people. Jamestown is to move forward to a brilliant future." He was right. (Courtesy Bradley A. Anderson.)

BIBLIOGRAPHY

Agostine, Rosella M. *Something About the Italians in Jamestown*. Jamestown: Copy. Craft, 1975.

Anderson, Arthur Wellington. *A Guide to Jamestown Historical Tablets*. Erected by the State of New York and the Jamestown Centennial Commission, 1928.

——. *The Conquest of Chautauqua: Jamestown and Vicinity in the Pioneer and Later Periods As Told by Pioneer Newspapers And Persons*, Vol. 1. Jamestown: Journal Press Inc., 1932.

Anderson, A. W., city historian, Jamestown, N.Y. *The Rushing Rapids*. (Limited edition brochure)

Bailey, William S., compiler. *Centennial of the Incorporation of Jamestown, 1827–1927*. Jamestown, N.Y.: Jamestown Centennial Commission Inc., 1927.

The Centennial History of Chautauqua County, Vol. II. Jamestown, N.Y.: the Chautauqua History Company, 1904.

Chautauqua Lake Steamboats. Jamestown, N.Y.: the Fenton Historical Society, 1971.

Dilley, Butler F., editor. *Biographical and Portrait Cyclopedia of Chautauqua County, New York*. Philadelphia: The Jas. B. Rodgers Printing Company, 1891.

Doty, William J., editor. *The Historic Annals of Southwestern New York*, Vol. 1. New York: Lewis Historical Publishing Company Inc., 1940.

Ebersole, Helen G. *Trolleys of Jamestown and Chautauqua Lake: A New Look*. Westfield, N.Y.: Chautauqua Region Press, 1998.

Edson, Obed, historian. *History of Chautauqua County, Illustrated*. Boston: W. A. Fergusson and Company, 1894.

Edwards, Elisabeth. *I Love Lucy: Celebrating Fifty Years of Love and Laughter*. Philadelphia: Running Press, 2001.

Goodwill, Thomas J., editor. *Centennial Celebration of the Incorporation of the City of Jamestown, 1886-1986*. Jamestown, N.Y.: Jamestown Centennial Celebration Committee, 1986.

Hatch, Vernelle A., editor. *Illustrated History of Jamestown, Chautauqua County, New York*. Jamestown, N.Y.: C. E. Burk, 1900.

Hazeltine, M. D., Gilbert W. *The Early History of the Town of Ellicott, Chautauqua County, N.Y.* Jamestown, N.Y.: Journal Printing Company, 1887.

Jackson, Robert H. *That Man: An Insider's Portrait of Franklin Delano Roosevelt*. Oxford, N.Y.: University Press, 2003.

Lannes, A. J. *Civic and Industrial Progress of the Swedish People in Jamestown, N.Y., 1848–1914*. Jamestown, N.Y.: Bergwall Publishing Company, 1914.

Leet, Ernest D. *History of Chautauqua County, New York, 1938–1978*. Westfield, N.Y.: Chautauqua County Historical Society, 1980.

Moe, M. Lorimore. *Saga From the Hills: A History of the Swedes in Jamestown*. Jamestown, N.Y.: Fenton Historical Society, 1983.

Mule, Dave. *Across the Seams: Professional Baseball in Jamestown, N.Y.* Mattituck, N.Y.: American House, 1998.

O'Brian, Jonathan D. "Builders of the Bond: The Cycle of Community Integration in Jamestown, New York, 1810–1886." Master's Project. University of Buffalo, 1992.

Young, Andrew W. *History of Chautauqua County, New York, From Its First Settlement to the Present Time*. Buffalo: Printing House of Matthews and Warren, 1875.